GREG
HILDEBRANDT

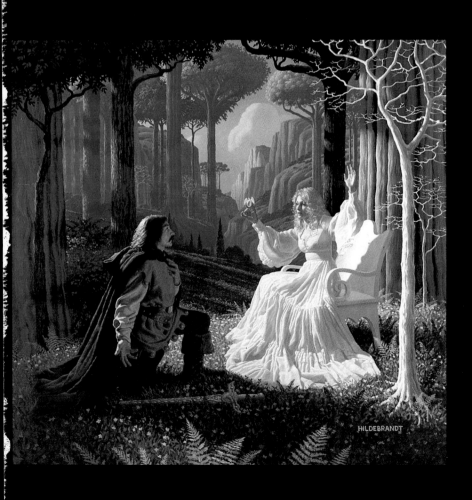

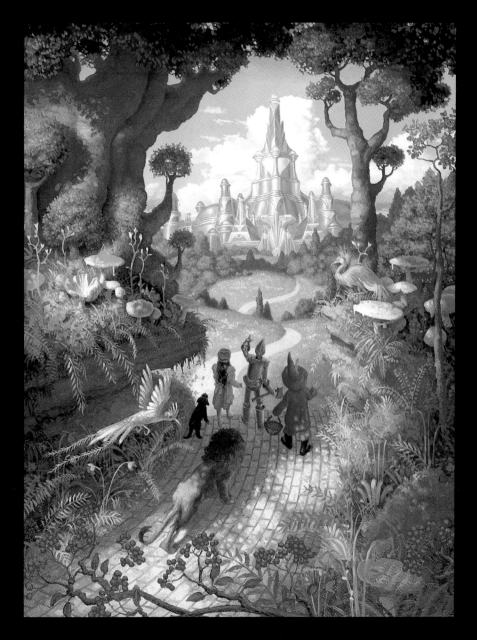

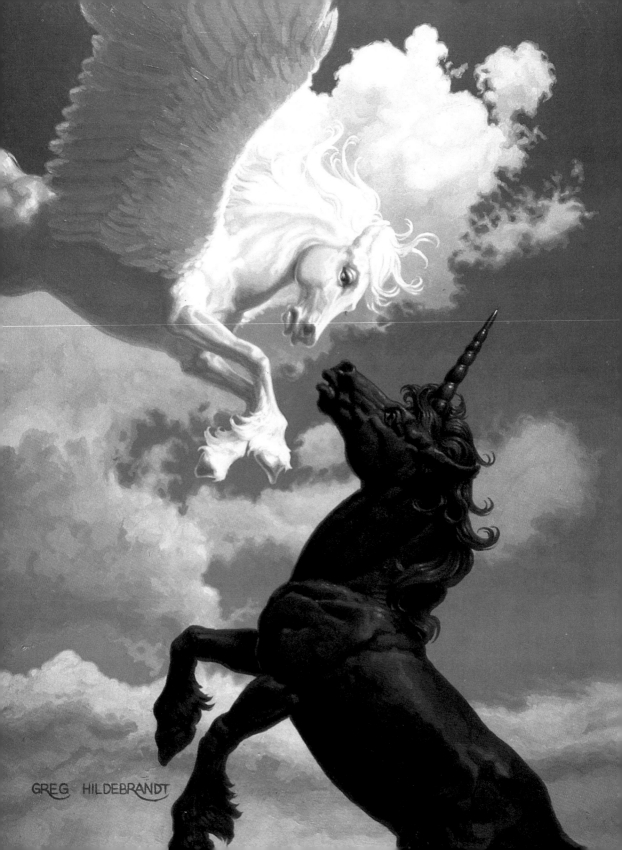

FROM TOLKIEN TO OZ

By

William McGuire

The Unicorn Publishing House

New Jersey

Designed and edited by Jean L. Scrocco
Printed in Korea by Samwah Printing Co., Ltd.
through Creative Graphics International, Inc., New York, NY 10010
Typography by TG&IF Inc., Fairfield, NJ 07006
Reproduction Photography by the Color Wheel, New York, NY 10017

Distributed in Canada by Doubleday Canada, Ltd., Toronto, ON M5B 1Y3, Canada
Distributed in the rest of the world by Feffer & Simons, New York, NY 10017
and other principal cities.

Thanks to Yoh Jinno, Joe Scrocco, Bill McGuire, Gene O'Brien, Heidi Corso and the entire Unicorn staff.

Printing History 15 14 13 12 11 10 9 8 7 6 5 4 3 2 1
 I. Hildebrandt, Greg — Themes, motives. I. McGuire, William,
1950- . II. Title.
N6537.H525A4 1985 741.6'092'4 85-8849
ISBN 0-88101-019-7

I dedicate this art book to my family and friends who posed for the characters in my paintings. And to each and every art student who dreams of becoming a professional illustrator.

May all your dreams come true!

Greg Hildebrandt

Here is a mystery.

It involves an artist and his creations. It concerns his pursuit for perfection, truth and resolution. He paints, his emotions flow, his spirit shines, his statement is made, his work is complete. But soon his spirit dims, his emotions change, a new issue begs to be resolved again through his art. This process, whose origin remains a mystery, shapes the artist; the deeper he lives life, the more he needs art.

Here is a history.

It took root when America was torn in civil war. Newspaper illustrations portrayed the conflict and an impressionable boy, Howard Pyle, was captivated by editorial illustrations telling the story. Later his illustrations brought many an art student to his doorstep, including N.C. Wyeth and Maxfield Parrish. Years passed and others, like Norman Rockwell, contributed to this tradition. Now another artist has joined that lineage, making a quiet history of his own. Like his predecessors, drawing and painting are indispensable parts of his nature.

Here is a magic,

a window into the creative process. The heart and mind are transformed through graphite and tissue paper, through brush and paint into imagery that stirs our senses and evokes our emotions, inviting our intellect to explore worlds familiar and unknown. It is ancient, this form of communication, primitive in fact; universal yet paradoxically personal. There is something immensely necessary about it all.

In the beginning...

The year 1939 brought, among many things, the German invasion of Poland, *The Wizard of OZ* to American audiences and identical twins, Gregory and Timothy to George and Germaine Hildebrandt in Detroit, Michigan. Soon thereafter, the family moved to a rural community tucked in the rolling hills near the Canadian border. Their house, a 100 year-old colonial, sits beside an old barn, chicken coop and garage. The Hildebrandts raised vegetables and flowers, did woodworking and collected antiques which echoed the history of our society.

Long before Greg knew what was beyond his country home, he had the impulse to draw. Germaine Hildebrandt, recalling her earliest memory of his drawing said, "It was a cold afternoon in early winter, and the Christmas season was approaching. My husband sat at the dining room table with crayons and a coloring book, showing the twins how to color. They instantly became involved, taking over the crayons. And wouldn't you know it, they stayed perfectly inside the lines! My husband and I knew it was very premature. From that moment, art became the mainstream of their lives. They were not yet two years old."

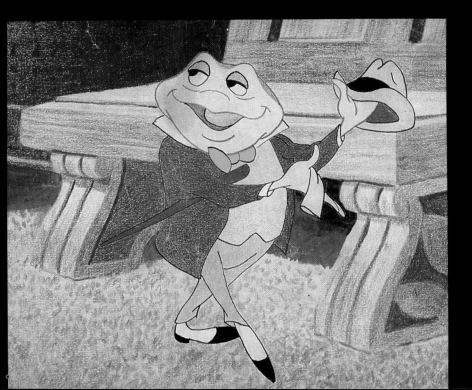

By age three, Greg's room was literally filled with crayon and color pencil drawings, sketched on sheets torn from giant rolls of paper. The drive to draw things as they appeared began to heighten. At four, he rendered realistic pen and ink drawings of Mickey Mouse. By five, his kindergarten teacher, witnessing the drawing of a mural on the blackboard, suggested Greg attend the Children's Art Institute.

Instead, he continued artwork on his own, and began creating hand puppets, marionettes and ventriloquist puppets; costumes and sculptures in clay, paper, cardboard, cloth and wood. By eight, comic strips came into their own. Recalls Greg, "I was drawing Superman from the cover of a comic book. His arms were outstretched and he was crushing something in his hands. I couldn't draw the hands and the basic anatomy properly. I kept erasing and drawing, erasing and drawing until I finally screamed in frustration and stormed from the house. Eventually I settled down and went back to the same drawing until I improved it. This pattern repeated itself for years. It exasperated my parents but never discouraged them from supporting me."

Not long afterward, family and friends were being sketched realistically and landscape paintings were rendered with sensitivity and detail. During this period, the desire to create animated drawings haunted him. The animated film, Pinocchio, seen many years before, remained vivid in his mind. Finally one day he pulled a book, entitled *The Art of Animation,* from a library shelf. It detailed Walt Disney's animation process. True obsession set in. Day and night Greg drew characters that moved as his thumb released the pages of the sketch pad.

In frequent walks with her son, Germaine Hildebrandt would fantasize aloud about the elves, dwarves and gnomes that inhabited the woods. Stories were created about these creatures, who were drawn or formed into clay models later that day. His parents instructed him to draw freehand, despite the resulting frustrations. Their constant support was a vital source of Greg's persistence in drawing.

As Greg matured, the qualities forming his being became more pronounced: a vivid imagination matched by a keen perception of life, an obsession for drawing, a love for fantasy, and a constant supply of energy. Seeing things, drawing things, making things — around and around it went from pencil to ink, cloth to clay — an avalanche of creations that turned the heads of family, friends and teachers.

High school, usually the beginning of a new experience, was eclipsed by a single gift, a hand-wound Brownie movie camera. At last, his animation drawings could be photographed frame by frame, then sent to the lab for developing. Greg remembers "The time it took to get the film back was forever! In class I wondered if the mailman had delivered that yellow Kodak box. After school, I ran home to get the film. I watched the animation for hours, enjoying the movement and analyzing its weaknesses, which appeared glaring once projected on the screen."

The 8mm camera fostered the construction of miniature sets in his parents' barn. The more all-day matinees Greg attended, the more his sets resembled those of Hollywood professionals. Science fiction was now the genre of his art. Spaceships on the moon; alien invasions; flying saucers encircling metropolitan cities; planets and stars in their birth and in their death — all drawn, sculpted, filmed and preserved in glorious 8mm film. Germaine Hildebrandt recalled the day the family automobile was saved from certain destruction, "Greg's grandmother ran outside, shouting that the car was parked near and to stop filming as a miniature city, which was being devastated by Martians, erupted in smoke and flame. Naturally her hysteria went unnoticed by Greg. All ended well anyway, for the car and the Martians."

By high school graduation Greg knew that art would be his life. To fulfill his military obligation, he joined the Army Reserve immediately after high school graduation. His drawing ceased during active duty, the only moratorium since his first coloring book. "The six months felt like six years," said Greg. "Circumstances were such that I could not create. My real nature stood at the main gates, waiting in anticipation for me to return."

Immediately following active duty, Greg entered Meinzinger Art School. It was located on the second floor of an old building in Detroit where the floorboards creaked and horns from passing motorists penetrated the room. The school was for realist art as opposed to the one up the street for modern art. The old and new would criticize each other, one was faulted for being outdated, the other was accused of being superficial and self-indulgent.

This academic experience was intense but brief. Greg studied basic drawing, perspective, color and design, anatomy and life-drawing. After eight months, he withdrew from school to work in the animation department of the Jam Handy Organization, the largest industrial film production house in the country. Their clients included General Motors; Campbell Soups; U.S. Steel; The Department of the Navy; and the Ex-Cell-O Corporation, patent-holders of the infamous cardboard milk carton. Greg worked in animation and live-action film production, drawing storyboards, designing and creating backgrounds for films that focused on world poverty in undeveloped nations. This work ignited a new social consciousness in him.

At the invitation of Bishop Fulton J. Sheen, Greg moved to New York to make documentary films about world poverty. He traveled throughout South America and Africa, shooting footage and recording interviews. The films were edited by him in New York and shown throughout the country. But his need to draw continually came to mind and he worried about losing these skills.

So in 1969 he returned to drawing, taking his portfolio to various New York publishers. Within several weeks he landed his first job. He and his brother illustrated children's books, advertising art, editorial art, and film strips. One individual, instrumental in developing Hildebrandt's career, was Carlo DeLucia, then art director for Golden Books. He provided the early opportunity and the needed encouragement in this highly competitive field. Their illustrations became marketable and even the Purina cat on the cat food box was a Hildebrandt creation. But after six years of commercial art, the artist in Greg screamed for more personally fulfilling work.

To compensate for such frustrations, Greg began to paint his dream images. At first these appeared as wild, often bizarre pictures, a striking contrast to the orthodox commercial illustration. Instead of viewing his art and instantly knowing what it was you now viewed it and said, "What is this? What is going on here?" If you asked the artist, he would say he did not know. And truly he did not. But it was clear that this art spoke from within him and about him. It was a direct message from his inner world.

His path soon crossed with someone, who thought his imagery made sense. Dr. David Abalos, professor of religious studies at Princeton University and Seton Hall University saw the paintings and knew they spoke an inner dialogue, a conversation about mankind and the human condition. He saw them as extremely personal yet symbolically universal. Greg brought his artwork to the college campus. Classroom dialogues brought a broadening of Greg's consciousness, not only in respect to his art but also to his personality. Once again he began to paint with a zeal.

But making a living through commercial art was still a necessity, so by day he illustrated and by night he painted. During these personally intense times, a *J.R.R. Tolkien Calendar* fell into his hands. Printed on the back cover of the calendar was an invitation for illustrators to create imagery for the following years' *Lord of the Rings Calendar*. The Hildebrandts, having read the trilogy some years before, had always wanted to illustrate this epic. They quickly assembled a new portfolio and made an appointment with Ian Summers, art director of

Ballantine Books.

On a cold drizzly day, the Hildebrandts moved through the wet streets of New York. Original artwork was wrapped in large plastic bags, protecting it from the rain. Once inside the conference room, their art was propped against the walls and table. Executives of the publishing house moved about, silently viewing the artwork. What they saw was just what they wanted. Ballantine offered the *Tolkien Calendar* to the Hildebrandts.

"When," was the question. "Promptly," was the reply. The deadline for all artwork was set — three months. This scenario, frequently recited to free-lance artists, was nothing new to the Hildebrandts. The joke, I need it yesterday, is no laughing matter to an illustrator.

Selecting 13 illustrations from four Tolkien books was a monumental task. With the choices carefully made, pencil sketches were begun and costumes were sewn for the models. Family and friends were cast in the roles of the characters and photographic sessions were staged, often with models holding cardboard shields or broom sticks that would be painted as shining armor or powerful swords. Within three months the photographs and sketches were transformed to finished paintings and presented to the publisher. Again those same executives filled the conference room. Handshaking and laughter was the order of the day. The calendar immediately went to press.

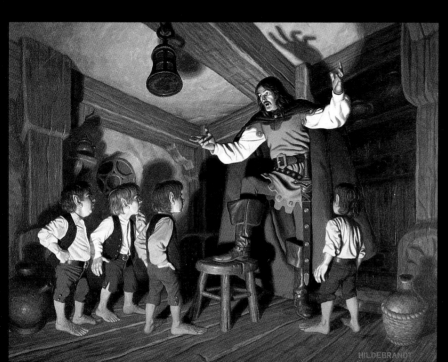

Following its publication, two important events occurred. First, it quickly sold out. Second, it created a following for the "Brothers Hildebrandt", a term coined by Judy Lynn del Rey science fiction and fantasy editor of Ballantine Books. Where would "The Brothers" take their talents now? Back again to Middle Earth, the land they loved.

By 1976 Tolkien's writings were well known to the American reader. College literature classes incorporated his material in course syllabuses and the cult following was growing steadily. Letters arrived at the Hildebrandt studio, first a few, then more, then in batches, stacks and piles. This was a new phenomenon, differing drastically from the usual procedure of artwork sent into the world and promptly swallowed by the great vortex, never to be recalled again. Now here was someone, lots of someones out there, awaiting their next Tolkien illustrations. "The Brothers" firmly resolved the forthcoming art would be their best work ever. Others, who knew them well, said the Hildebrandts always responded that way about their next work.

The *1977 J.R.R. Tolkien Calendar* eclipsed the previous one in an artistic and business sense. More calendars were printed, more were sold. The art thrived on a marriage of fantasy and reality. It accentuated an emotional experience and reaffirmed human values intrinsic to many societies, to many individuals. Its imagery spoke to the instincts and we listened. The Hildebrandts made tangible the world that lived silently, perhaps symbolically in us — our Middle Earths.

A ground swell of fantasy titles flowed from the Tolkien tidal wave and the Hildebrandt telephone rang like an alarm. Numerous publishers requested fantasy and science fiction cover art for new titles. The Hildebrandts accommodated many, sandwiching illustrations between paintings for the third *Tolkien* calendar. Ballantine Books editor, Judy Lynn del Rey, who never seems to lose the pulse of the fantasy reader, matched Terry Brooks, author of *Sword of Shannara* with the Hildebrandts. Black and white interior paintings and cover art were completed. With the release of the book, America had a new epic fantasy and the Hildebrandts captured the hearts of more Americans.

Ad agencies, especially those with clients in the motion picture business, wanted Hildebrandt art also. One agency, Jon and Murray, requested layout art for a film entitled, *The Island of Doctor Moreau.* While there, Greg noticed poster art for another movie, *Young Frankenstein.* He inquired about additional art, but none was planned. The Hildebrandts said they would complete a painting of Frankenstein by tomorrow. The art director laughed as they departed. He did not laugh the following day when they returned with the promised art. Although it could not be used, the art director would remember this episode when George Lucas requested a finished painting for his new

movie. But that was in the future and for now the third *Tolkien* calendar needed completion.

A wave of enthusiasm crested in the closing weeks of the Tolkien illustrations. The publisher had woven a fuse and the publicity machine had lit the match. Readers and fans eagerly awaited its publication and friends frequently came to the studio to catch first glimpses. No one was going to be disappointed. The Hildebrandts, physically drained by the intensity and duration of the work, had mixed their magnificent colors and formed their arched rainbow which yielded thirteen new Tolkien treasures.

The *1978 Tolkien calendar* flooded the country in August. By the new year, one million Americans had opened their calendar to the Hildebrandt images. But even before the paint dried on the last illustration, their film backgrounds germinated the idea of using their original artwork as preproduction material for a live-action *Lord of the Rings* film. Unknown to them at the time, Ralph Bakshi had already begun production of an animated *Rings* film.

It was a letdown when they learned of the Bakshi project. Tolkien's *Rings*, which had been their domain for three years, was in the hands of someone else. The film side of their personalities ached for the silver screen and the time was right for a live-action fantasy film. After numerous discussions they decided to base a film on an original story — a fantasy novel of their own. *Urshurak* was born in the weeks of May, 1978. Conceived from the outset as a motion picture, it would first be sold as a novel. Bantam Books bought the rights after seeing an outline, several chapters written by Jerry Nichols, and colored storyboards of the characters and environments.

The Hildebrandts worked exclusively on *Urshurak*, except for a single piece of artwork. It came through the ad agency of Jon and Murray who under the gun to have completed artwork for the movie *Star Wars* remembered the twins who did the Frankenstein poster. The art director called the Hildebrandts. Back then it was *Star* What? and George Who? They completed the artwork by painting for forty-eight continuous hours, at times working on the painting simultaneously. That image was soon to be placed on the front of T-shirts worn by hundreds of thousands of people. If the Hildebrandts were not a household word, they were certainly well known in the laundromats of America and their connection to the major fantasy works of the 1970's was certainly complete.

Meanwhile, back at *Urshurak*, the Hildebrandts assembled a team of creators, a la the Disney method of film production. Writers, musicians and businessmen worked together, developing the preproduction materials necessary to sell the story to a motion picture company. Chapters were outlined and text was written, storyboards were

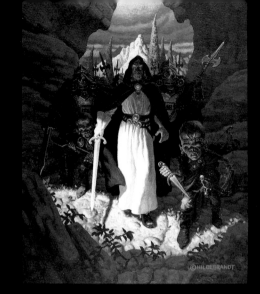

drawn and music was composed. These elements played off one another, gradually shaping the story; the book and the film version. The book was published in the fall of 1979, but the film rights were never bought. It was, as Joseph E. Levine said after viewing an audiovisual presentation, "The finest preproduction material I have ever seen but the film is far too expensive to make." Other studios concurred and the film idea died. The book continued to sell steadily, but to the Hildebrandts, a piece of the floor was missing.

Sometime during the replacing of that floor, they decided to pursue separate careers. It was a decision born out of the necessity to establish independent identities, something that weighed heavily on them, especially following the era of "The Brothers Hildebrandt." Greg replied, "I was extremely nervous during those months and insecure about my art, even about my ability as an artist. The experience of working alone was so unusual that it frequently broke my concentration just enough to make me feel different in front of a sketch pad or painting. It took a while to feel just me in the art."

But a while was not that long. Greg's agent, Jean Scrocco, had been working through publishing houses, ad agencies and motion picture studios. Her contacts were extensive, so selecting the better projects for Greg inevitably brought the best out in him. Together they planned, acquired, scheduled and completed projects in a systematic fashion. Greg said about Jean, "You are as good as the people you work with. Without the right people, especially Jean, making the right connections, in a sense guiding me, I would have felt like I was producing artwork in a closet. More rewarding work and more fulfilling art is as much the result of the agent as it is the artist."

By the end of 1980, Scrocco was collaborating with director Peter Yates and producer Ron Silverman, who were in the planning stages for a motion picture entitled, *Dragons of Krull*. Greg was hired to create the preproduction art for the film. Working directly from the script he designed the characters and their costumes, along with environments, weaponry and creatures. Within six months Yates had 160 pieces of artwork. But in the true Hollywood tradition, complications set in and when the script was radically altered, the Hildebrandt material was never used.

Greg, aware of the workings of the motion picture business, did not sit on his hands, waiting for the good word. By the end of July he completed a painting designed for the poster art market in the U.S. and Europe, as well as a signed limited edition art print portfolio comprised of thirteen paintings, entitled *Gods and Goddesses*. The characters in these paintings were lit in such a way as to enhance the maximum use of color. They were strikingly different from previous Hildebrandt material. The portfolio sold exceedingly well, but this work was actually the calm before the impending storm. The avalanche rumbled in the early weeks of August.

The idea for a series of illustrated cloth-covered classics was the outgrowth of numerous discussions between Greg and Jean Scrocco. She saw the need for heavily illustrated, beautifully designed books. To Greg, the classics offered a gold mine of imagery and such books were a throwback to the early works of the giants of illustrative art, Howard Pyle, N.C. Wyeth and Maxfield Parrish. The classic series was presented to several major publishers and it was Simon & Schuster, who saw the potential and bought the concept.

Charles Dickens' *A Christmas Carol* was selected as the first classic. As we enjoyed the warm days of August, Greg contemplated Scrooge and snowy, bitter nights. Outlining the text yielded the scenes for illustration and initial sketching began. Somewhere early in that process William Morrow and Company called with an inviting

project of their own, *King Arthur and the Knights of the Round Table*. This was another story from Greg's long list of classic favorites. The avalanche slid closer.

Mary Stewart, one of the most popular novelists today, had written Mary Stewart's *Merlin Trilogy*, an interesting perspective on King Arthur and the Middle Ages. A calendar, bearing the same name, was planned for publication in 1984. Greg was commissioned for the artwork and outlined that text while continuing his work on Dickens. By March of '82 he was painting *A Christmas Carol* and sketching the Merlin Trilogy. His studio was literally filled with art and a visitor would either stand or go through the frustrating process of moving artwork from the chairs only to find there was no place to put it. By the final days of May, an incredible thirty paintings for the Dickens book were completed. No celebration occurred, the images for the Merlin Trilogy followed immediately.

The work continued, occupying fifteen, sometimes eighteen hours per day. Telexes arrived from Europe, requesting more Hildebrandt imagery to fill the void created by his poster art that had sold out. Puzzle manufacturers tested the waters, only to find his fantasy imagery was in huge demand. Publishers wanted cover art for their new book lines. Greg did some, like *The Forbidden Mountain*, others he reluctantly turned down. Old Merlin was still waiting for his final colors on the drawing boards. The avalanche had arrived.

Greg dug his way out by completing the *Merlin Trilogy* in late October of 1982. Mary Stewart wrote to Greg, "Of course the conception of author and artist rarely coincide, but I have learned that the artist has the advantage: with time and familiarity, the artist's conception of the scene gradually takes over, and were I to start another Merlin story now, it would be your people who moved about in it."

Through the close of 1982 and into the new year, Greg varied his work between poster art and album covers. More importantly though, he continued to analyze his art as he created it, trying different techniques, experimenting with color and perspective. But the isolated hours necessary for his work were taking a toll on his personality. There existed a need for human encounter and teaching at the Joe Kubert Art School offered the opportunity for social interaction. "Teaching caused me to consolidate my knowledge. I organized the technical information into packets while still conveying broad concepts. This experience brought changes in my art as well as the art of my students."

By March of 1983, Greg had completed thirty sketches for the second book in the classic series entitled, *Greg Hildebrandt's Favorite Fairy Tales*. Twenty sketches would be converted into paintings, the remaining done in pencil renderings. Greg thoroughly enjoyed this

project. Stories like *Aladdin* and *Sindbad* conjured childhood memories. I also made him receptive to another project, one that rooted him clearly in his youth. In May he, along with his agent, began designing the third book in the classic series, entitled *A Christmas Treasury* containing, among other stories, *'Twas The Night Before Christmas*. Once again it was winter in summer. But this artist did not mind the change of seasons.

In late July the television industry, gearing for their fall promotional campaigns, wanted unique promotional art. ABC-TV asked Greg to provide imagery. During this time, work on the *Favorite Fairy Tales* and *A Christmas Treasury* illustrations were temporarily interrupted. Greg watched an uncut nine hour screening, of *Mystic Warrior*, much of it without the accompanying sound track. Extremely sensitive to issues in the film, he became emotionally committed to the project and completed a stirring piece of promotional artwork for the film. Just as he was preparing to return to the classic series, ABC called again.

Stars, fifty of them from prime-time shows, had to be painted in a single scene. The artwork was completed within twelve days and sent to the network. Not long afterward, agents for some of the stars called the art director of ABC, who in turn called the artist's agent, who naturally called the artist with requests such as: so and so looks too old, can we make him younger? Or, you know who should be in front not in the back, right? Or, do you think it is possible to move what's his name to the left? Well, several things occurred as a result of this. First, Greg had already returned to the fairy tale artwork. Second, someone at the network got a migraine. Third, AT&T made a bundle on all those phone calls.

Throughout the winter Greg worked exclusively on his fairy tale book, completing it in January 1984. He returned to *A Christmas Treasury* and as the snow fell, the finished paintings accumulated. This family holiday book, published in early September, sold strongly in the crush of the Christmas sales. The classic series now had a firm foundation.

In New York, Young & Rubicam Advertising Agency had finalized an ad campaign with one of their clients, Dr. Pepper. The soft drink giant decided to base a sales campaign on fantasy imagery. Ads for TV and print media, featuring fairy tale characters enjoying Dr. Pepper, would certainly make their soda appear out of this world. The agency commissioned Greg and by early August Jack and the Beanstalk along with Goldilocks and the Three Bears were created. When Jack's and Goldilocks' thirst was finally quenched, Greg returned to poster artwork and planning sessions. His schedule for the remain-

der of 1984 and well into 1985 was being built methodically by his agent, Jean Scrocco.

Greg began sketches for a book, *Peter Cottontail's Surprise*, the first storybook for this rabbit, who came to the American consciousness in the 1950's with the popular song, "Here Comes Peter Cottontail." Although 19 full-color paintings were completed in the weeks prior to the Christmas holidays, Peter would not hop out of his warren and into the stores until the first day of spring, 1985.

In September, Greg began to sketch an American classic, *The Wizard of OZ*. The most difficult aspect of his work was to conceptualize the illustrations from the text while avoiding the preconceived images from the Judy Garland movie. The *OZ* art, extensive in scope and concept, contained 25 paintings and 15 black and white illustrations. The artwork, penetrating in its sensitivity and explicit in detail, was completed in four months. Recalled Greg, "The paintings felt right as I created them. Some of the characters, particularly the Wicked Witch of the West, are completely different from what is commonly expected. It is an attitude much like I felt when painting the *Lord of the Rings*. You do what you feel is best, combining the author's text with extensive research. You work it out totally, then you wait to see if it works for those who look at it. Taking the classics and illustrating them is tricky business. It takes gall to try to visually pin down what people see strictly in their minds. It becomes magic, when what I put down matches what people have in their imaginations. That is the core of successful illustration."

So where are we now? On a voyage through the world of Bram Stoker, chasing Dracula through England and into the land across the woods, Transylvania. Will we pursue him relentlessly through poignant text and intriguing, eerie illustrations? Why yes, for it is far better to catch Dracula than to have him catch us. Wouldn't you agree Mr. Hildebrandt?

"These I paint for me..."

A pathway cuts through the landscape. From the distance it appears as a thin string stretched through dense wilderness. Up close it is a broad expanse, too wide to see in a single eyeful. We begin walking and the distance remains the distance. We have been fooled, the tiny pathway is actually the endless road.

Along it are signposts — artwork that reveals a journey. It seems familiar, this land, these signposts. But soon the pathway diverges and runs solitary, curving, turning, twisting into distant and virgin territories. We are lost, only the signs signal us.

Now we read them with new attention. They say they are not signs but stepping stones. We wonder if this is true. They say they provide access through uncertain and turbulent times. We want to believe them. These signposts, like the notches carved in the tree bark by pioneers, mark the way through unknown lands. They reflect struggle, hope, individuality, despair, oppression, tenderness, solitude, triumph, beauty, and love.

At various points artistic hands reach into the blackness that extends endlessly from the edge of the pathway. Something grabs hold and yanks the artist in. There in the darkness, hidden from the naked eye, the artist creates and as the sign is formed, the light and the pathway return. The artist is free to move on but the sign must remain there for others to see. Such art speaks the universal message; all of us are making our way through an uncertain world.

Artists want to create their own imagery. They need to define and reflect their world to themselves and others. Their creations shape that which is essentially void of form. Signposts make tangible certain aspects of life that we seek to embrace. So the pathway is traveled, the art is created, the sign is read and awareness dawns slowly over this landscape, which has been made new again.

Floating Planet

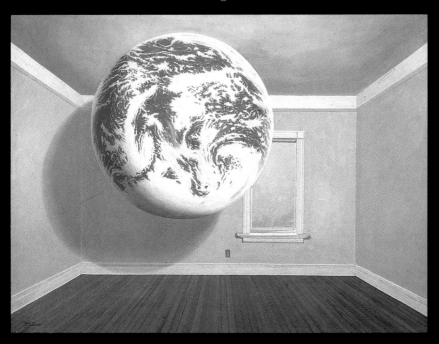

"I painted this painting in 1971, on vacation at the Jersey shore. I rented a house from a friend, site unseen, and took my family for the week. I realized when I got there that this environment was as chaotic as the one I had just left, if not more so. People were running back and forth with plastic lawn chairs, trying to claim their own little piece of the beach. So I locked myself in a room with a sketch pad, away from the chaos. This image came out of the general concept that the world in its entirety can easily be confined in a very small space. As I looked through the blinds I saw the world going hither and thither and realized the universe is very close and actually can be in your own backyard."

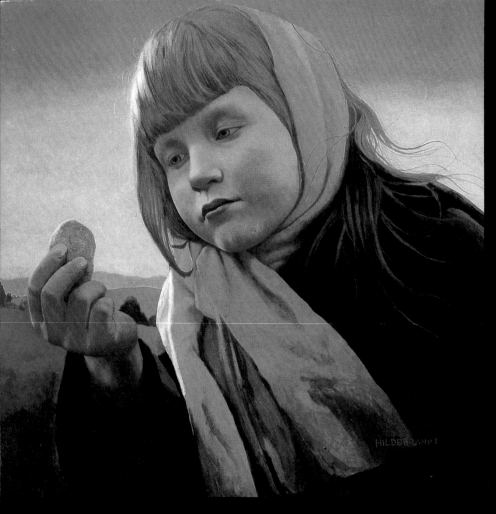

Mary 1974

"Unlike the first painting of Mary where my use of color was very subdued, this painting was done with a very powerful use of color. This style was derived after approximately nine years of learning more about color and the use of color. I went back to the style of the impressionists, using maximum color everywhere, even in the shadows. Today, I see components of each that I like."

Mary 1984

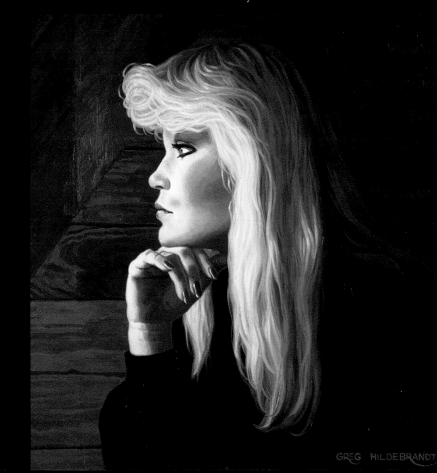

"I painted my daughter, Mary when I was in a period of photorealism. No, even beyond photorealism, I was obsessed with what I considered micro-realism. This meant being as detailed as I could possibly be to the point of taking a microscope and viewing an object. The need was for an infinite amount of detail. I spent approximately three weeks on this painting and could have easily spent three more."

GREG HILDEBRANDT

Gregory 1980

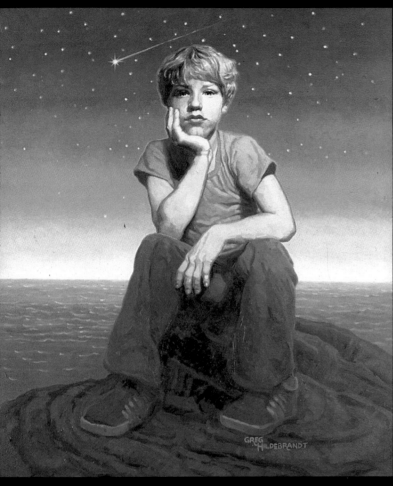

"I was anxious to paint my son before he moved into his early teenage years. The impact of *Star Wars* caused an obsession with the Fantasy of Space. So I was trying to capture the attitude of dreaming as he stared into space."

Gregory 1983

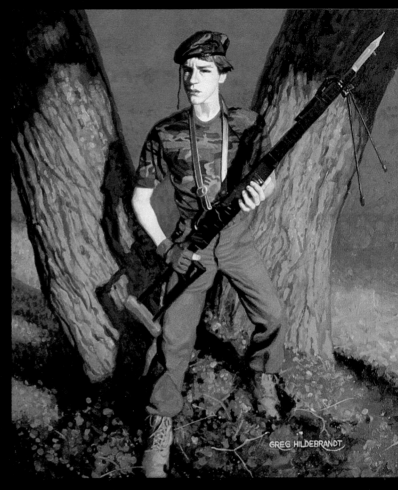

"I wanted to paint my son so I asked him his preference. He chose to be painted in his mock army fatigues, with a handmade fantasy gun. This was a period of his life that dealt heavily with the fantasy of war. The feeling of the painting is strong, so I used strong colors to visually describe this aspect of my son's adolescence."

Laura 1984

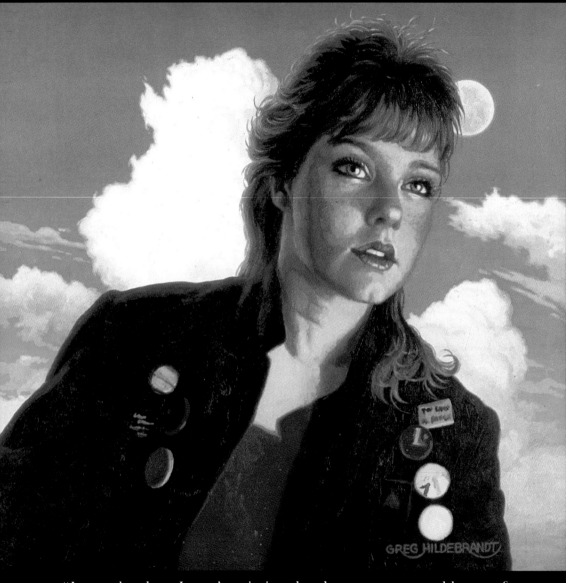

"In my daughter Laura's painting she chose to wear an old coat of mine from the 60's. I guess this was Laura's way of portraying her own personal rebellion. By painting my children in this way I have a permanent retrospect of certain stages in their lives. This is something I hope to be able to do every three years, creating a pictorial history of my children for my children."

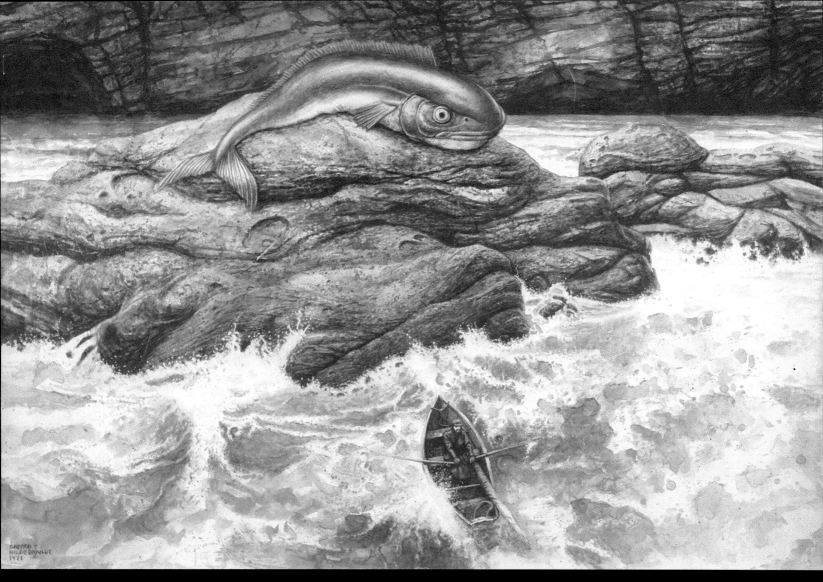

Fish Dream 1970

"I remember vividly seeing this dream in my sleep. I was rowing a boat, unaware that this huge fish was behind me. I didn't know where I was rowing to but I know I was frightened. I believe this dream came from feelings in my life that were based on the proverbial fish-out-of-water. Both the fish and the man are in the wrong environment, the roles are reversed. I was primarily doing commercial illustration and I was frustrated. I wanted desperately to do some paintings for myself and in so doing get my feet back on land."

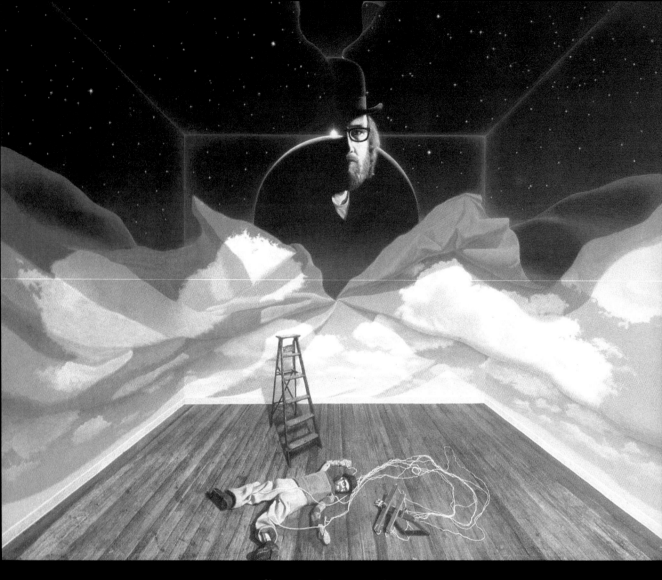

Puppet Dream 1971

"This image came to me when I was almost asleep, drifting into a subconscious state. A series of images appeared all relating to being a twin, which I am. This was the time in my life where I was feeling the need to paint alone. I needed to break away from the past and into a my own world. In the dream I was walking along as a puppet, carrying a ladder. I set the ladder up and climbed it. At its top I ripped open the sky and suddenly I was in space. Then the space tore open as if to take me out of one reality and into another. This was the beginning of my breaking away from the twinship as it pertained to illustration."

The Art of Advertising

You awaken and advertising art greets you from your tube of toothpaste, from the TV tube, in the morning paper, in your mailbox, inside and outside the bus, train or taxi, from billboards, at your office, bank and restaurant. It presents itself as you relax in your health spa, movie house, seashore resort or mountain hideaway. It is drawn on clothing, boldly displayed in the face of the sky and cleverly positioned in the bottle cap of a soft drink. It permeates from the metropolis to the reclusive island, it can even be found in your dreams.

Advertising art was spawned in the Greek civilization, when engraved announcements of plays were distributed throughout Athens. The Roman Empire displayed its awesome power in wall murals depicting their legions conquering enemies of the state. The Middle Ages, with its specialization of labor, brought craftsman who labeled their shops with signs made by commercial artists. Their art served more as an informative device than a decorative one. The Renaissance also gave birth to the first ad printed in the English language, announcing the availability of books for purchase. In 1788, a London newspaper ran two advertisements with simple line drawings and illustrated advertising took hold.

The Industrial Revolution transformed America into a mobile and transient society. A media network proliferated from the technological developments and from those who paid money to advertise. Producing and consuming became the voice of the marketplace and specialized companies began writing the passwords and casting the images that fostered product recognition and sale. These were the advertising agencies. Introducing a product, emphasizing its uniqueness, and above all selling the commodity became a sophisticated and systematic procedure. Advertising catered to individual personalities and became the personalized link between the manufacturer and the consumer, the voice which whispered that happiness could be realized in goods and services.

Essentially, an advertising agency is a service company that plans, creates, produces, and places advertising. With the usual administrative arm of a business, the ad agency must pool the talents of a number of specialists, including market research, account executives, copywriters, art directors, type directors, proofreaders, print production experts and traffic controllers, who monitor all creative and production work in the agency. They, together with their client, develop new and distinctive ways to sell a product.

The image in an advertisement, along with a catchy tag line, is designed to make an instant and impressionable mark in one's mind. Greg Hildebrandt's artwork, distinctive for its use of light, color and characters, has found a natural home in advertising art. His diversity of style enables him to create artwork that compliments the product and the selling theme.

Usually the art director of the agency will contact Greg, offering the job along with a set of guidelines. These include a general layout of the ad, the kind of imagery, the number of initial sketches required, deadlines and fees. Greg completes several initial sketches and submits them to the art director, who confers with the agency's creative staff and its client. A single sketch is selected, changes are sometimes made in layout or design and the sketch is returned to Greg for painting. Most times one or possibly two pieces of art will cover an entire campaign in magazines, newspapers and poster ads. A single ad, appearing in a repetitious manner, is an effective strategy that serves to remind the public of the initial selling proposition. Establishing the message, making it memorable and frequently exposing it is the cornerstone of the industry.

The agency will send Greg a copy of the finished ad prior to its release in the media. Sometimes, however, Greg will see the ad for the first time when he turns on the TV set, picks up the morning paper, a magazine, or the mail and the ad greets him with surprise saying, "Remember me."

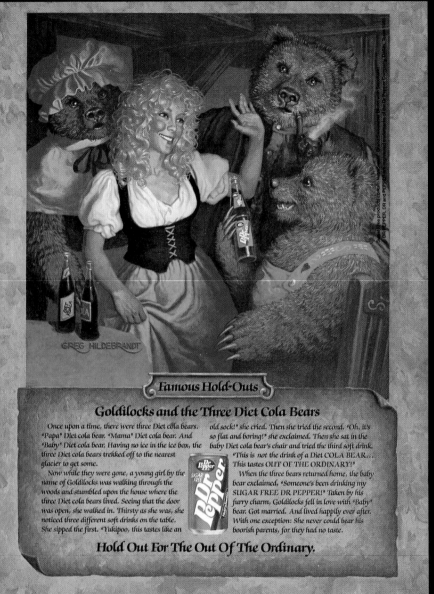

"Every time I paint an epic fantasy scene with dramatic lighting I always joke about wanting to add in a beer can or a hamburger wrapper, just for the fun of it. I finally got the chance and they paid me to do it."

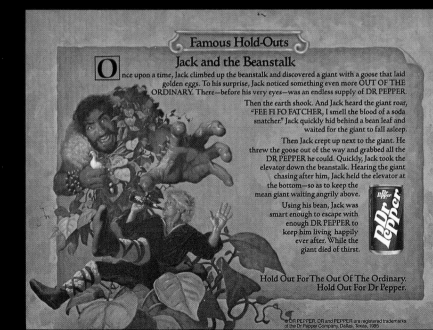

WILL THE CABLE YOU BURY COME BACK TO HAUNT YOU?

Why Chemguard is the ultimate protection for cables.

How our system works.

BRAND-REX

GREG HILDEBRANDT

Creamer, Inc

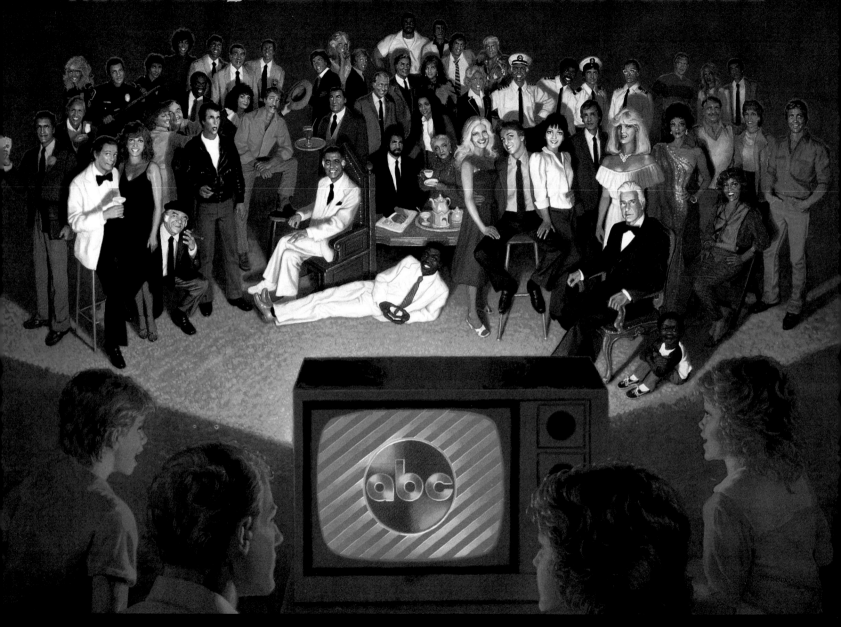

"The challenge of painting 53 people from photographs was intense. Especially considering the fact that each photograph was shot in a different lighting set-up and none of the stars were at the right angle for my composition."

Collector's Fantasies

Fantasy, a product of our creative imagination, is portrayed in mental images. Sometimes these are brief, other times they form the foundation upon which episodes, stories and even epics have flourished. Books, motion pictures and TV have helped to activate our fantasies, enabling us to experience that which otherwise would remain outside our daily encounters. Fantasy provides a forum through which we can temporarily live our life on a grandiose scale. The experience — of being submerged deep in the ocean depths, hurled through black holes in outer space, an eyewitness to the dawn of man or to the lives of giants, dragons and witches — touches a vital aspect of our psyche. The powerful lure of fantasy may be in part a response to a variety of dilemmas that face modern man. Fantasy may assist us in grasping solutions to some of those problems.

A fantasy is several things at once; an expression in symbolic terms of an inner vision of the self, a vehicle to explore alternatives and possibilities in your life and a tool to learn more about your needs and desires. It is also a way to entertain yourself, to briefly escape and thus relieve the tension incurred by daily living. Creative use of our imagination can provide a novel perception to some of life's problems.

Some people have taken a close look at their fantasies. They have recorded them in journals or have drawn or painted them. Still others, who have wanted to see themselves in their fantasy, have called upon the talents of Greg Hildebrandt. Through Greg's painting, they have in essence permanently and realistically captured themselves in their fantasy and now have the ability to look at themselves in that world. Such paintings have come to be called "Collector's Fantasies", since those, who have had their fantasy painted, are also avid art

But for these collectors, the process leading to the finished painting was in itself a journey into the world of imagination. They first discussed their fantasy with Greg, reviewing such elements as clothing, time of day, surrounding objects, other people and especially the prevailing feeling or mood. Notations were made and Greg researched the time period that most closely paralleled the imagery in the fantasy. Initial sketches were made and again consultation occurred between the artist and client. With approval of the finished sketch, it was time to create costumes.

They were made exactly like those drawn in the sketch. Props were also created and a photo session was scheduled. The collector, dressed exactly as imagined in the fantasy, took a pose that mimicked the one in the approved sketch. Under the warm photolamps, the collector remained motionless as dozens of polaroid shots were taken of the scene.

Then Greg worked alone. The approved sketch was transferred onto a masonite board coated with white gesso paint. Using acrylic paints, he first completed the background areas, including all objects. Then he concentrated solely on the characters. Working steadily and methodically, he used the polaroid shots which held the expression of the character fixed and alive for him to capture in paint. The lighting on the face, already calculated in the desired manner when the photolamps were positioned, emphasized the human emotion and generated the mood of the scene. The folds in the clothing, the shadow area across the body, the detail in a belt buckle or boot amplified the realism. Fantasy took a creative step closer to reality.

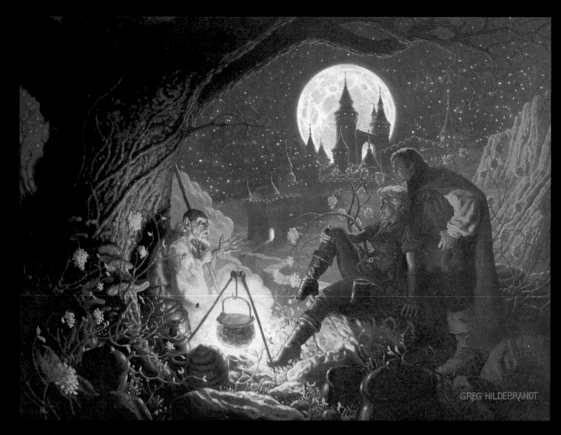

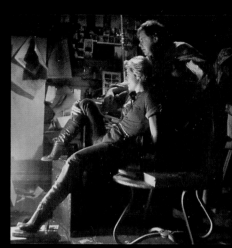

"As Greg Hildebrandt's agent I have always admired his
talent. As his publisher I am proud to be able to bring his
magnificent illustrations to the public. But as his friend I
have had the privilege of getting to know the man as well as
the artist. This has enabled me to understand the sensitivity,
depth, detail and balance of his nature which he brings
forth in his art. My fantasy has always been to have lived in
the days of Robin Hood. Greg made this fantasy a reality.
This painting is a possession I shall always treasure."

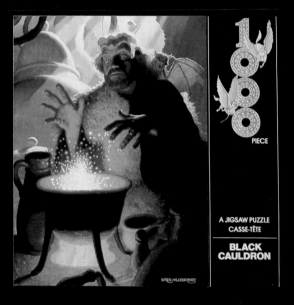

American Publishing Corporation

"I have been a great admirer of Greg Hildebrandt's work for many years. I always wanted a painting of my fantasy done by Greg. The character of the wizard is one that I love and it was very exciting posing for Greg. The end result was outstanding and I will treasure it forever."

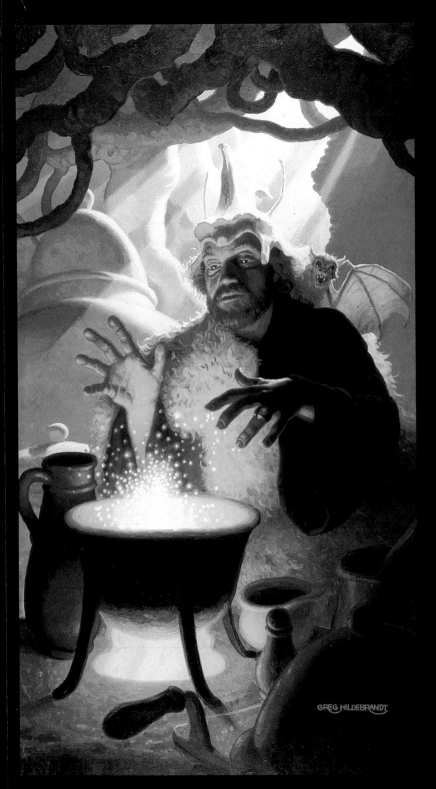

In the private collection of Michael Resnick

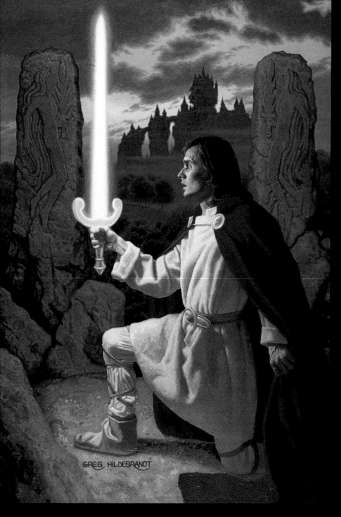

In the private collection of Gene O'Brien

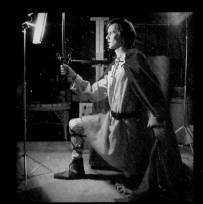

"I've always considered Greg to be one of the top masters, if not the master, of fantasy art. Ever since I first saw his work with the Tolkien calendars, I've seen how diligently he treads that ever elusive fine line between fantasy and reality. His creations exist and yet they don't. That's a master. His attention to detail is obsessive.

"Having taken a long shot by contacting his agent, I had my own fantasy painted. It's an experience that I treasure and am honored by. It's not something he does everyday, you know! If he doesn't like it, his name's not on it!"

Gene O'Brien

Fantasies Forever Coloring Book

Consumer Product Design

The old axiom, "Never judge a book by its cover," couldn't be further from the truth. In a literal sense, it is done so often that a single book may now be published with several different cover designs (or the same cover in different colors) in an attempt to appeal to a broader market. In a practical sense, the initial appearance of any consumer product is crucial to its sale, especially when product variety is extensive. So consumer art is faced with a fundamental responsibility; to grab hold of the consumer's attention and develop an immediate interest in the product. Whether it be posters, puzzles, greeting cards, magazines or stationery, the art serves as the initial salesperson for the purchase.

Art used as a consumer product in itself, is always designed for the age level and price range of a specific market. It characteristically contains large figures, bright colors and imagery appropriate to that market. Stores and catalogs already offer complexity through their choice of vast inventories, so consumer art with busy scenes and lots of incidentals appears too complex to the consumer. Instead consumer art must be basic in form, impacting and different from the mountain of other products bombarding the eye.

A poster is a prime example of consumer art. Its imagery must be carefully analyzed to address the targeted audience. The poster is actually a self-contained idea, telling its own story in a single image, without the use of words. It often focuses on a particular emotion, and through the arrangement of elements; character, setting, action, it establishes a mood and evokes a feeling in us. In short, it acts as an emotional billboard, providing a direct message which we can actively integrate with.

Some posters have enjoyed a lasting quality because their image touches some universal cord in us. The posters of Maxfield Parrish or Norman Rockwell strongly reflect emotional aspects of human experience felt by many and are able to transcend time and remain relevant year after year. These posters are in contrast to those that become popular as a result of a fad or trend. Such posters last only as long as their subject material remains popular. When interest wanes, the poster becomes outdated and disappears from the stores and the walls of the consumer. The wheel of merchandising — directed by this endless cycle — will quickly roll to the poster image that reflects the newest trend in the marketplace and again the cycle will begin.

Consumer art is a way in which people, who love art but cannot afford original works, can purchase them. The art, created by Greg Hildebrandt for a consumer product, is approached with the same intensity, preparation and expertise used in the making of art for himself, for another, for a children's book or an illustrated classic. The quality of his work is not dictated by the ultimate purpose for the art. It is governed instead by the discipline of the artist and the obligation he has to himself to make only art and nothing less.

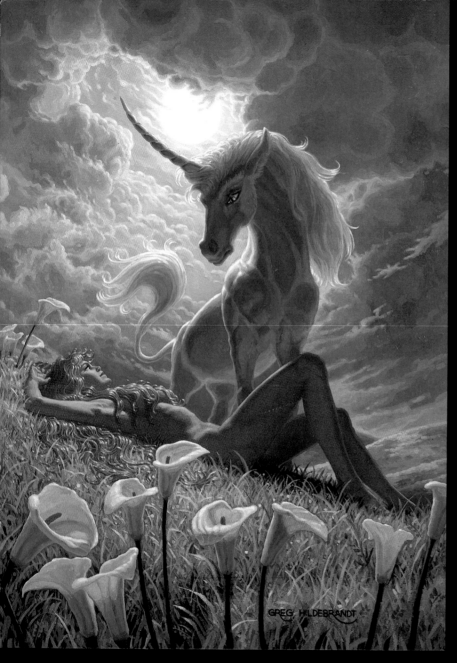

Angel of the Gods 1981

Warren Paper Products Co.

Warren Paper Products Co.

Bastei — Germany

Posters by Verkerke Reproductions USA, Inc.

The Winged Messenger 1982

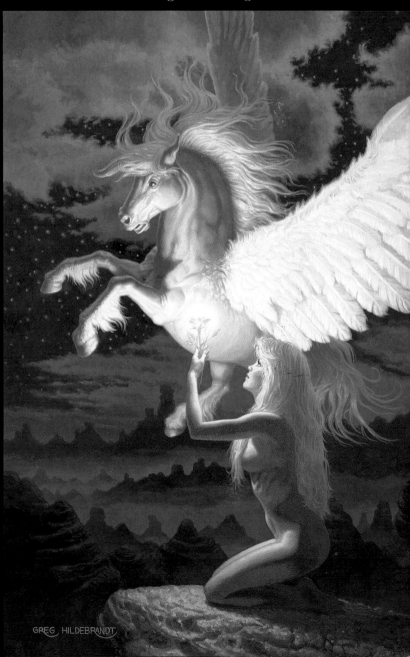

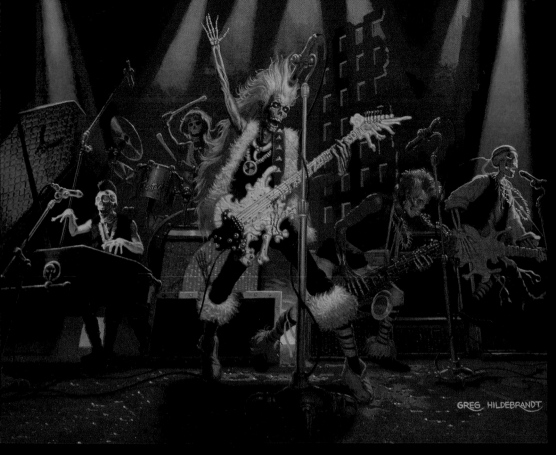

Totentanz 1983

"The word Totentanz in German stands for the dance of death.
Franz Lizst wrote the music. The cords he used were forbidden in
the middle ages because they sounded satanic. Totentanz is an
ancient idea and I used the idea to create this imagery."

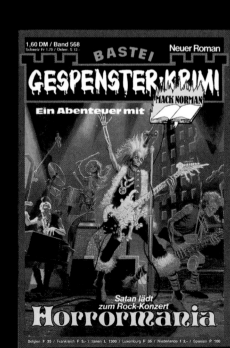

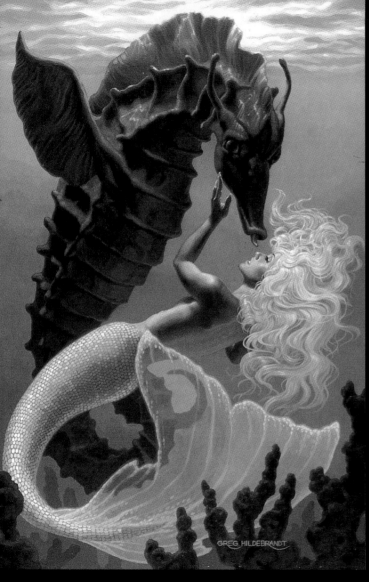

Mermaid's Passion 1984

The Ebony God 1984

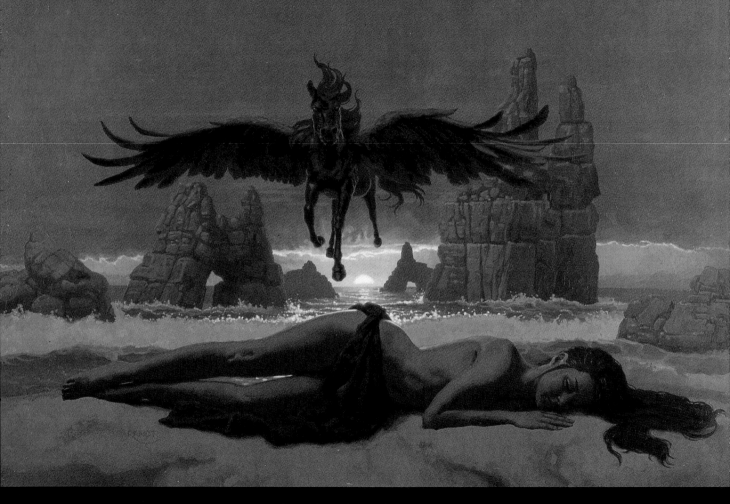

Sea Nymph's Flight 1984

Movie: Preproduction & Poster Art

The artist, when creating preproduction art for motion pictures, works primarily from a film script. The actual look of the film is influenced immensely by the preproduction artist, who draws the actual characters, settings and props. The art is then presented to the creative nucleus of the film; the director, producer and writer. Stories set in a particular historical period would use sets, costumes and props appropriate to that time. But fantasy films present a different and more involved situation. The look of everything from costumes to vegetation, from architecture to various life- forms, in short the physical world itself, must be created, drawn, and made believable.

When the script has been read thoroughly, the artist draws initial pencil sketches defining the characters, their clothing, environments, buildings, artifacts and weaponry. The director and producer work directly with the artist in developing these ideas. A second set of sketches, incorporating these ideas is made in color. More meetings between the creative team result in additional pieces of art, some being completed as finished paintings.

Composites are also painted, illustrating the key scenes in the story. These and finished black and white pencil sketches will serve as a guide for the production designer, art director, costume designer, makeup artist, special effects artists and a team of other craftsmen soon to be hired.

With the key elements of the film defined, the artist creates storyboards, small drawings the size of comic strip panels. They provide a visual translation of the script, allowing the cinematographer, actors, actresses and film crew to clearly see the intentions of the director. Below the drawing is often scribed the dialogue of the character, comments concerning the musical score and the sounds of the scene itself. Thus the key components for each scene is defined, providing a common concept for all to work toward.

The role of artists as well as specialized craftsmen have greatly expanded in filmmaking today. Their talents, along with advancements in technology, have produced such films as *2001: A Space Odyssey*, *Star Wars* and *Raiders of the Lost Ark*. Working together, artists and technicians have brought a reality, powerful and majestic to the fantasy film.

"No sleep! That was the key to the preproduction art for *The Dragons of Krull* film. I was extremely nervous and anxiety-ridden on this project. It was the first thing I was doing without my brother and I had shaky knees when I began. But as I got further into it I started to gain self-confidence. This, for me, was the most important thing at that time in my career."

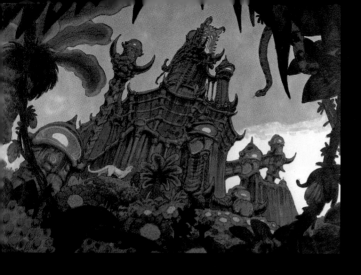

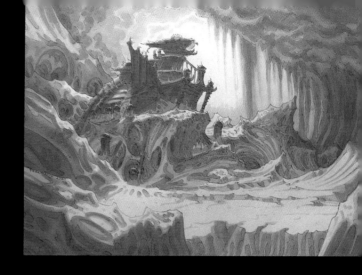

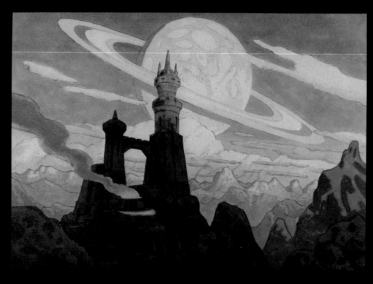

Designs for environments done in water color markers

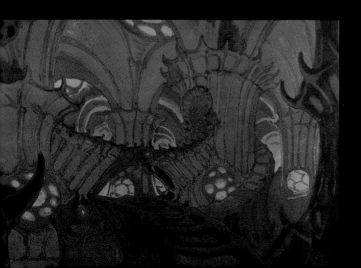

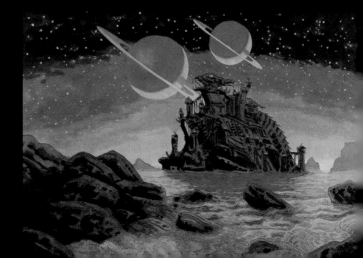

"It's always a challenge to try and sum up a movie in one image. You have to grab the spirit of the film and condense it. Since movie poster jobs usually have to be done overnight, I really have to gear myself up to produce. So I take a lot of vitamins and just do it."

"If I was painting the *Star Wars* poster today I might change the composition slightly but in general I still like this painting. In retrospect, I think it's funny that I had to get two of my friends to pose for Luke and Leia because of the deadline, and now years later, I realize just how many people have walked around with these unknown people on their chests."

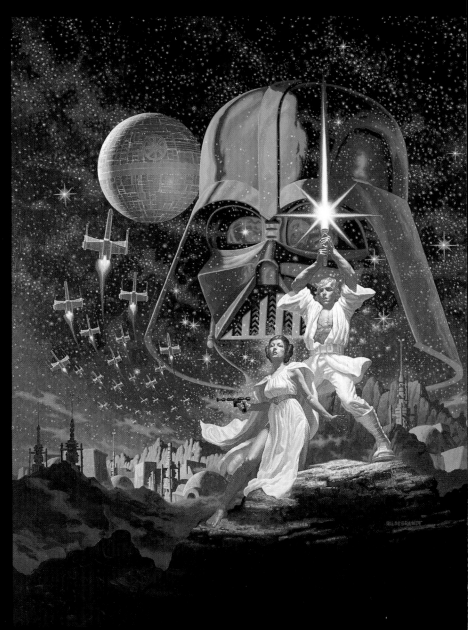

Mystic Warrior 1983

American Broadcasting Co

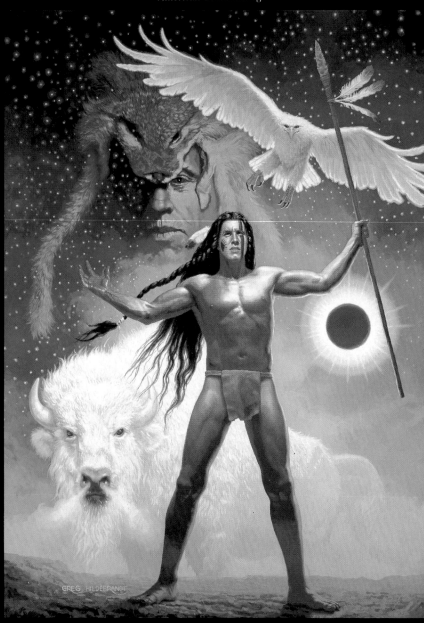

Clash of the Titans 1981

Metro-Goldwyn-Mayer

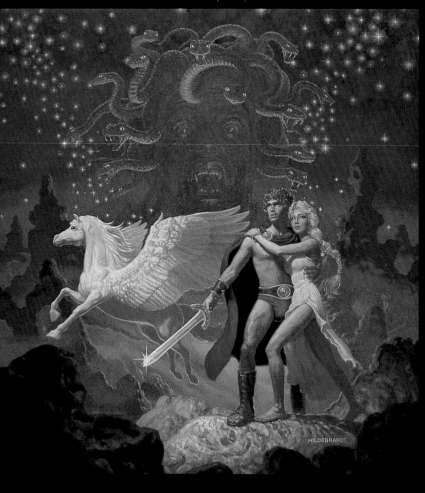

"This is the final painting my brother and I worked on together."

"I have always loved the American Indian. I made many an Indian costume when I was a kid. So watching 9½ hours of uncut film to come up with this image was very intense. I found it mystical and heaped with legend and folk lore."

Limited Edition Portfolios

The limited edition art portfolio is designed for a specific collectors market. Usually there are between six and ten individual color plates inside. The portfolio cover is signed and numbered by the artist to insure that only a specific number of portfolios will be sold. This protects the collector's investment.

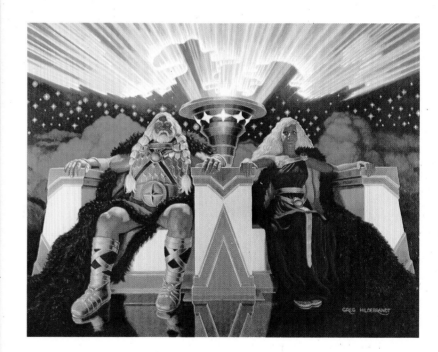

GODS & GODDESSES

GREG HILDEBRANDT

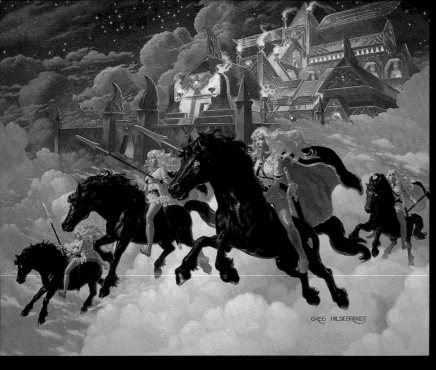

Ride of the Valkyries 1981

Thor 1981

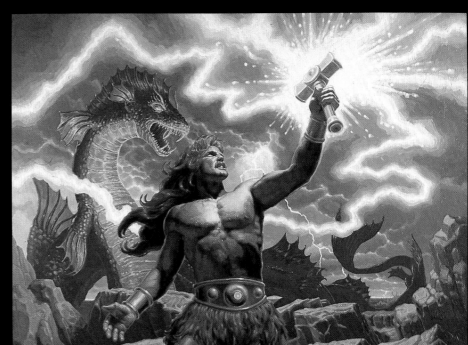

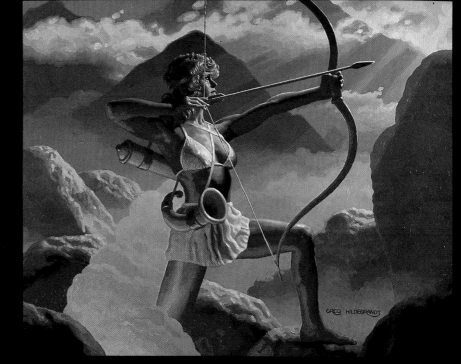

Hel 1981

Diana 1981

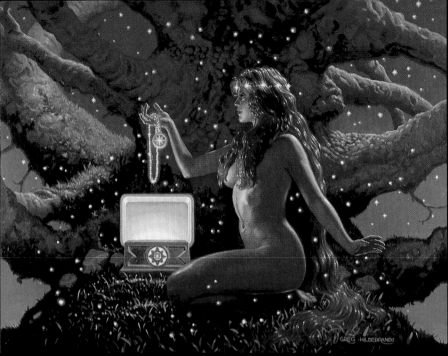

Freyja 1981

Loki 1981

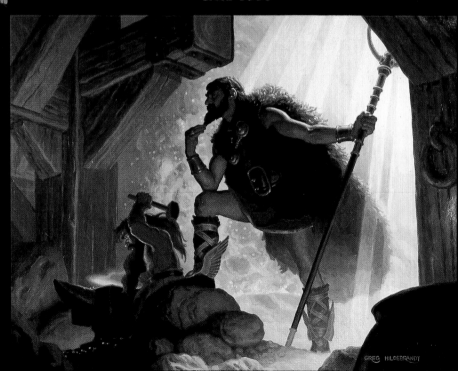

Calendars

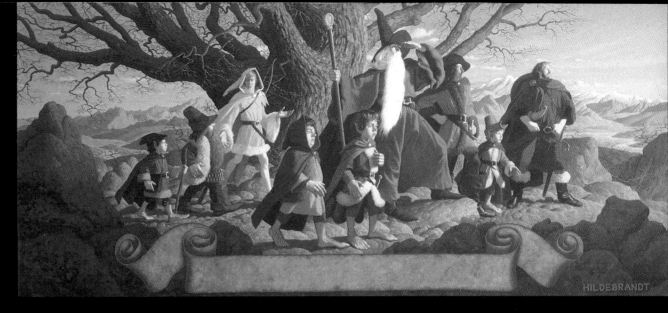

"Can you see them yet?" asked 1 of the hobbits. The wizard, shielding the sunlight from his eyes, replied, "No, not 1, 2, or 3 of them are anywhere in sight."

"Do you think they're really coming?" asked a 2nd hobbit.

"They said 4 or 5 would arrive today," replied the wizard, "And the remaining 6 would be here on the 28th. I said all 9 of us would meet them here, atop the stony knoll, beneath the oak tree on the 22nd."

"The 22nd," said a 3rd hobbit. "Today isn't the 22nd, it's the 20th."

"No," cried a 4th hobbit. "It's only the 19th."

"No, no, no, this is the 18th, so don't confuse things," shouted the dwarf.

"Wait a minute, I'm the wizard and I ought to know. This is — hum, let's see now, if Thursday was the 17th, Friday was the 18th. That means Saturday was the 19th and since this is Tuesday, 3 plus 19 equals 22."

But the 3rd hobbit interrupted saying, "This is actually Wednesday, so make it the 23rd."

"Look," said the tall thin man who had been listening to all this, "We left the village on the 15th, didn't we? We traveled for 3 days, stopping for 2 days on the 17th. We departed again on the 19th and traveled 3 more days, making this the 21st."

"That's what I said," shouted all of them at once. "It's lucky I have such a good sense of time," added the wizard. All nodded their heads in agreement. We'll just wait here for them to arrive. After all, October is a beautiful month," declared the wizard.

"October! bellowed 1 hobbit, I thought this was September."

"No, no, no," said the 2nd hobbit, "This is early November, I'm sure."

"November! How can that be? I don't even remember the summer," mumbled the wizard. There was a moment of silence as the 9 looked perplexed at 1 another.

"Sure you do," said the 3rd hobbit. "Remember when those 13 or was it 14 . . . "

And so it went in the days when calendars did not exist. Aren't we fortunate to be spared such uncertainty?

Calendars — everyone uses them and recently they have become personal statements. The era of the "family calendar", the one calendar used by everyone, has given way to calendars that express specific, individual tastes. In 1985 more than 1,500 different wall and desk calendars were available in the marketplace.

The subjects of calendars are as varied as books and many are tie-ins to well known book and movie titles. They, in effect, advertise and sell each other. Such is the case with the *J.R.R. Tolkien Calendars* and Mary Stewart's *Merlin Trilogy*.

The Tolkien calendars capsulated the trilogy and the Hobbit, an introductory novel to *The Lord of the Rings*. In 1974 Tolkien's own illustrations were used for the first Tolkien calendar. It was followed by a second in 1975, illustrated by Tim Kirk. Then in 1976 "The Brothers Hildebrandt" began calendar illustrations that set a precedent. The 1978 calendar sold over one million copies, prompting a wave of book-related calendars, especially fantasy-based, which continues to this day. The publishing industry had a new product, the illustrated calendar. What was conceived initially as a sideline business, became a powerful profit center for the industry. Although the calendar has been hanging on walls for 400 years, it does more today than just give us the date.

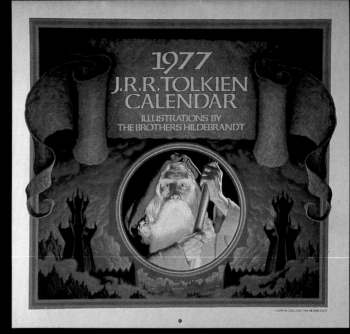

Ballantine Books

Ballantine Books

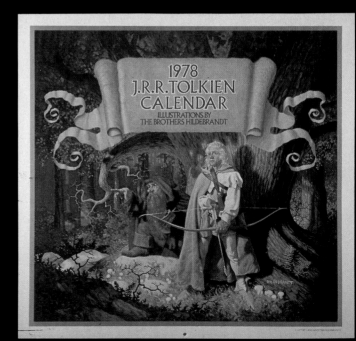

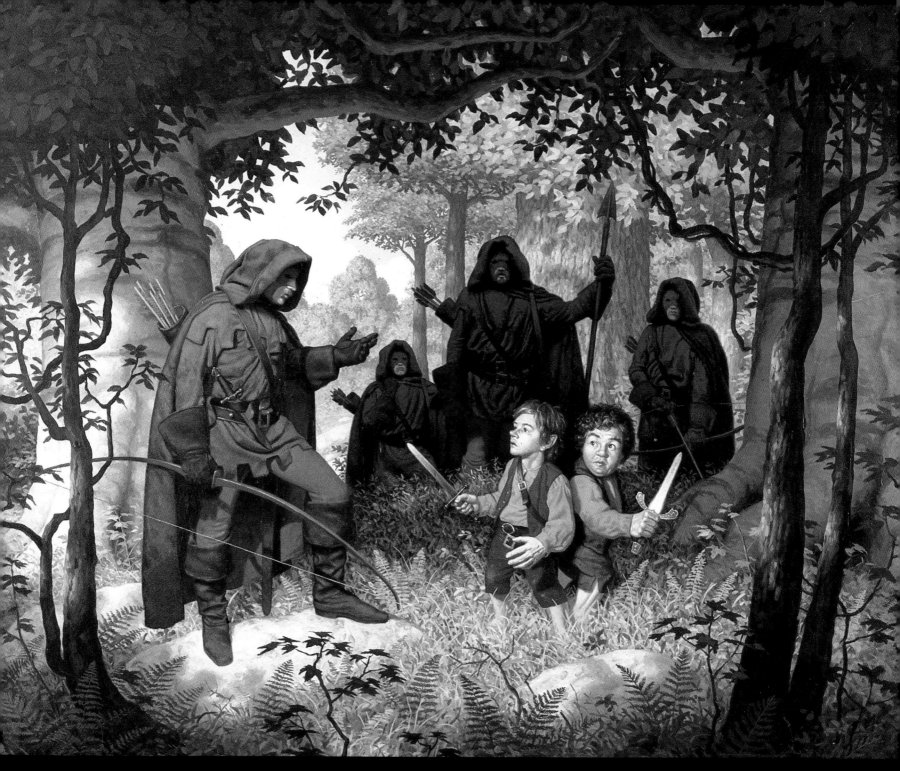

Faramir 1977 J.R.R. Tolkien Calendar

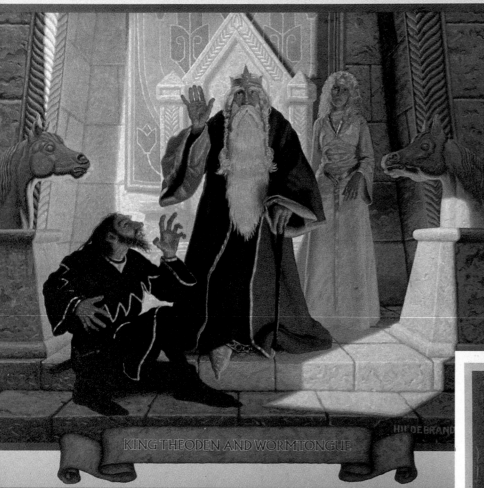

KING THEODEN AND WORMTONGUE

1978 J.R.R. Tolkien Calendar

1978 J.R.R. Tolkien Calendar

"Calendar images have to be self-contained because there is no text. So unlike a book illustration they each have to tell their own story and they have to be pleasant for people to view. You have to illustrate specific scenes in a general sense."

"The calendars I've painted have primarily been from books, and you have to try and cover the entire book. You have to hit the key characters, environments, moods and lighting conditions. Since people look at the same image for thirty to thirty-one days you have to choose your illustrations carefully. You have to decide what people want to look at every day. Sometimes that gets tricky."

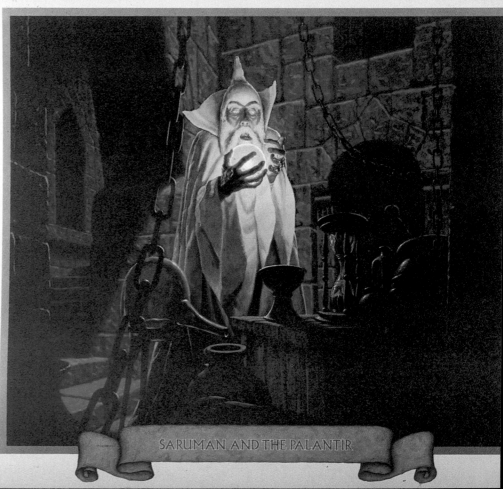

SARUMAN AND THE PALANTIR

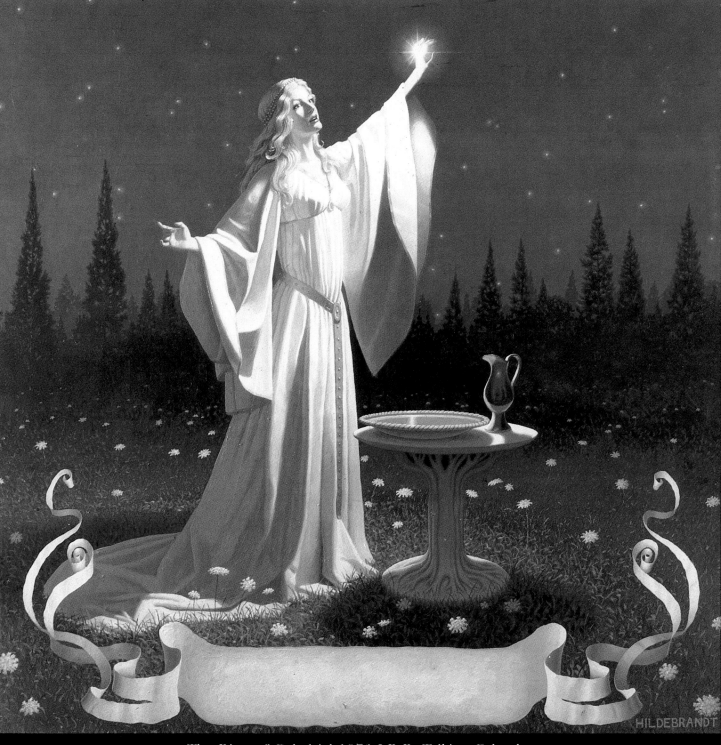

The Ring of Galadriel 1976 J.R.R. Tolkien Calendar

MARY STEWART'S
MERLIN
CALENDAR · 1984

Paintings by Greg Hildebrandt
Based on the novels of Mary Stewart
The Crystal Cave · The Hollow Hills · The Last Enchantment

GREG HILDEBRANDT

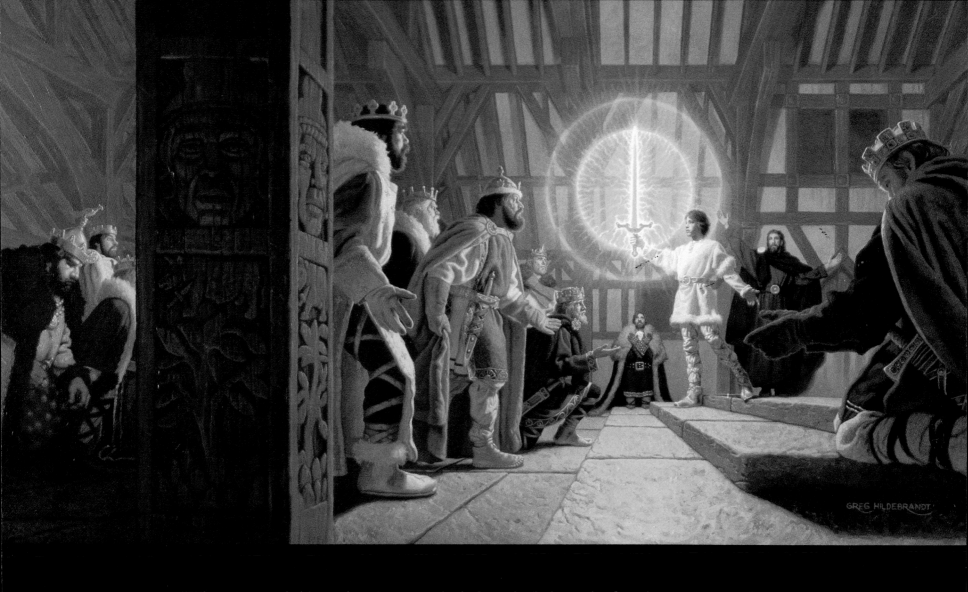

"When I started this project I was particularly excited about the fact that Lady Mary Stewart was still alive. Her *Merlin Trilogy* is a major fantasy work with a large following. J.R.R. Tolkien was dead when I illustrated his works and I was continually wondering whether Lady Stewart would like my art and whether it would fit with how she imagined her characters."

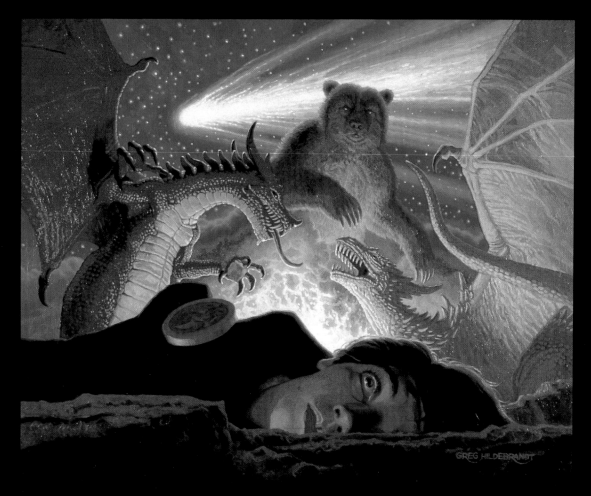

The Prophecy 1983

"I had an incredible feeling that my art had satisfied
Lady Stewart when I received a letter from her and she
said that her words and characters were now moving
around in my world."

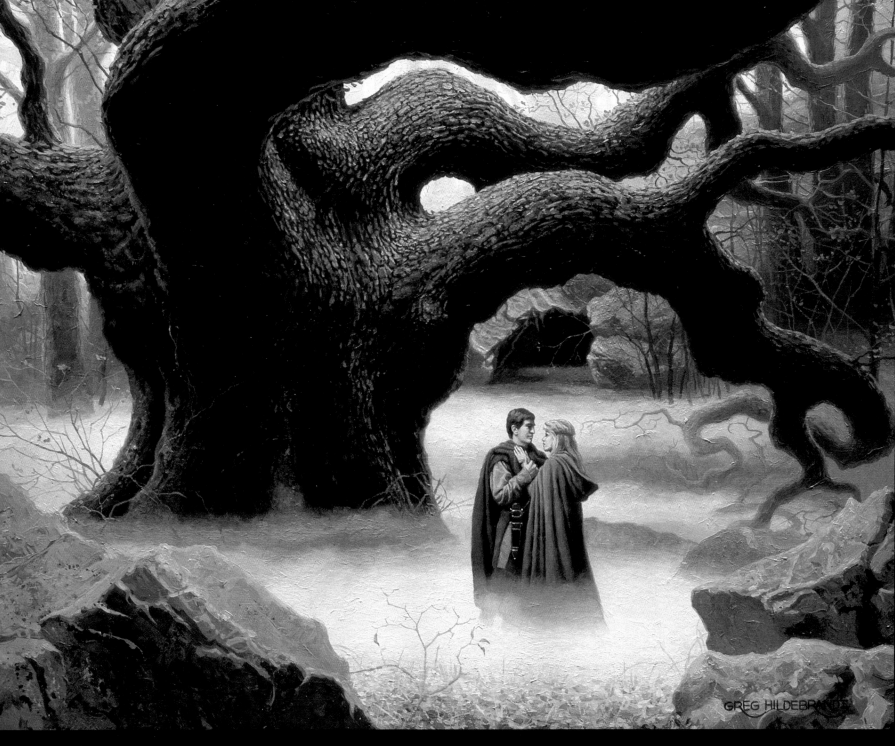

The Prince of Darkness 1983

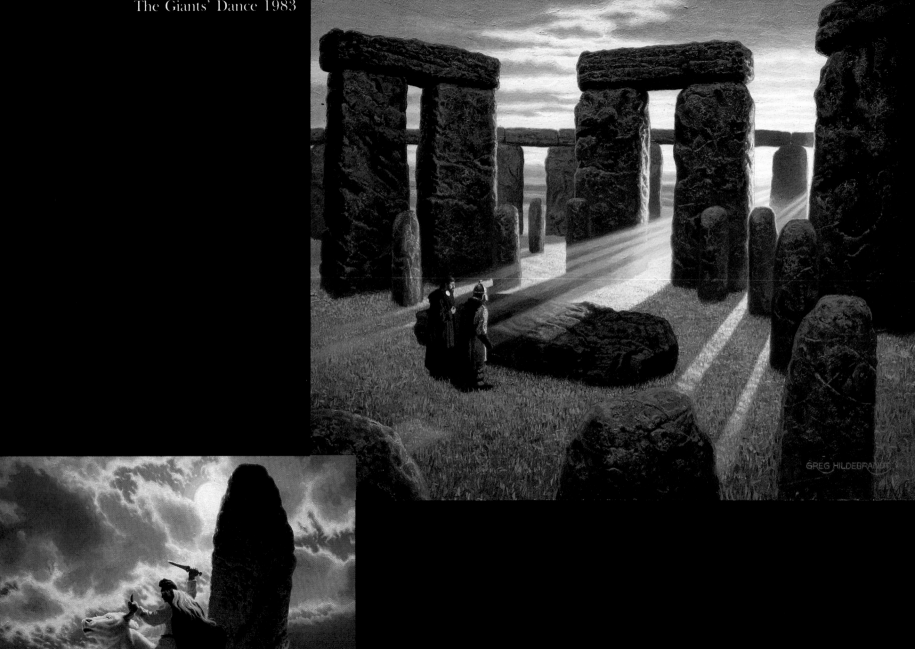

The Giants' Dance 1983

GREG HILDEBRANDT

Deception at Tintagel 1983

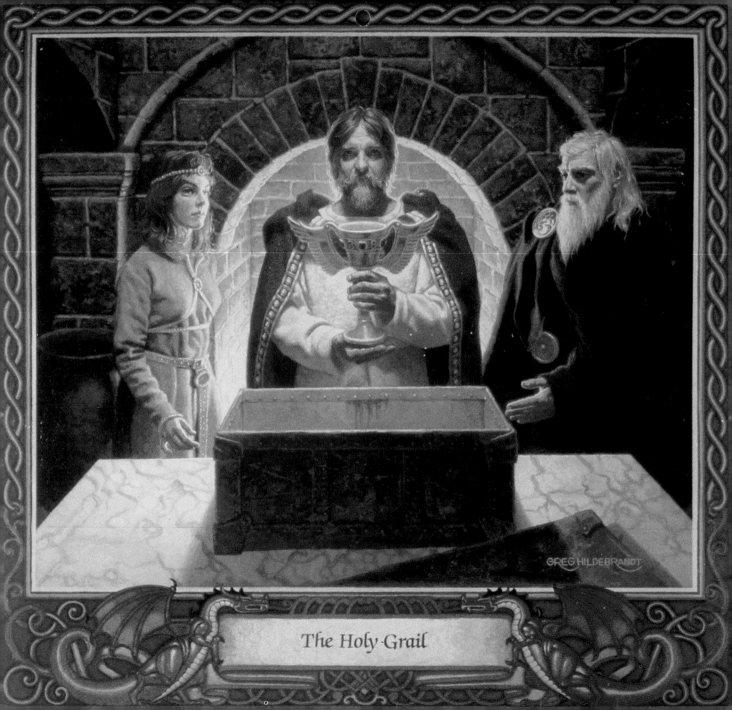

The Holy·Grail

GREG HILDEBRANDT

The Classics

On the deck of the ship, the salty winds beat against your face. You squint as you peer across the foamy waves. The skin under your eyes has gradually wrinkled, forming permanent lines on your face. With the passage of time you look much like your captain. The creaking of the wooden masts under full sail squeals in your ears. You are afloat in the middle of nowhere with a captain who is loosing his mind. He has grown maniacal in his pursuit of the great white whale. He has become deaf to the voice of reason. Up close you can feel his insanity crawl over you. You are forced to swallow it.

The captain challenges the whale. It retaliates, ramming the ship. Overboard, you are hurled. The water is frighteningly turbulent yet you cannot feel its wetness. Between the swells you see the captain snagged in a harpoon line and pulled like a puppet to his death by the whale. You cling to debris as the ship, sailors and beast disappear, leaving only the blanket of sea rolling over itself.

You close the pages of Moby Dick, and sit engulfed in pity and terror, wondering what if . . . ? Might there not be some way for man to feel more significant, less tiny in this ocean of life? The answer seems to be a silent "No, not in this story, not in this way."

When the wonders of nature are not enough in themselves, man is driven to create his own and we are desperate to watch. You know the house, shadowed in full moonlight, looks sinister as it stands alone from all others. But you go inside anyway. There in one of the rooms, is a laboratory and a young scientist, busy with chemicals and test tubes. You do not interrupt but silently stare. He administers a substance to something outstretched beneath a sheet.

Suddenly it moves. The yellow glow of the lantern reflects the horror in the scientist's eyes. It is the same terror running through you yet you remain, transfixed with the sight. A monster, assembled from dead flesh, ugly and powerful, comes alive. Bringing life to a lifeless body should have brought fame to this scientist. Instead it brings horror. He runs from the laboratory never noticing you beside the doorway. The monster rises toward you. Your heartbeat thuds in your chest. Your arms and legs grow weak.

But you turn the pages of Frankenstein and read more. There is something attractive in his ugliness, something sensitive and sad about his existence and something monstrous about the society.

Such is the power of the classics. Their characters wrestle with us throughout the scenes, involve us in circumstance that we love and hate. For a time they take us apart, piece by piece, and when we are reassembled we feel different, at least for a time. The Greeks knew this, they called it catharsis. They came to their plays to be emotionalized, to be changed and they were. Story-telling became an art and in time certain stories, frequently built on outstanding characterization, became classics. They are the memorable stories with a recognized worth and a lasting significance.

Whether it be captain Ahab and Moby Dick, Victor Frankenstein and his monster, Dracula and his victims, Scrooge and his ghosts, Dorothy and the wonders of OZ or Santa and his midnight ride, these classics vivify a timeless element called — genuine emotion. The masters of the written word: Shakespeare, Melville, Shelley, Stoker, Dickens, Baum, Stevenson, Verne, Clemens and a host of others have captured personality in its varied and amplified forms. They have revealed to us what we find most intriguing in life — people.

And characters are the focal point of Greg Hildebrandt's illustrations. They are realistically painted in scenes that weld them tightly to the unfolding drama of the story. Hildebrandt's unique use of lighting makes the characters come alive, their facial expressions and body mannerisms graphically broadcast their emotions.

Ironically enough, they are alive, for the characters are real people, chosen carefully by Greg. None are professional models. They are his family, his friends, people he meets in the food store, post office or on the street; an architect, a grandmother, a Federal Express carrier, a dentist, a store owner, a restaurant hostess, a student, a lawyer, an auto parts dealer, a hair stylist, a rock band booking agent, a bulldozer operator. They become the characters, they exhibit the emotions, they live momentarily the kindness of the good fairy, the anger of the Wicked Witch, the curiosity of Dorothy, the tenderness

of Tiny Tim, the fear of Scrooge, the strangeness of Marley's Ghost, the evil of Dracula, the confusion of Jonathan Harker, the courage of Dr. Van Helsing, the happiness of Santa Claus. They embody the emotions that support the theme of the story. As we read and look at the illustrations, we become emotionally involved. We practice catharsis in the Greek tradition.

Greg chooses certain people for certain characters because their physical qualities match the description found in the text. When a character is less than specifically defined, which is often the case, the illustrator's personal interpretation serves as the guiding principle for character selection. Greg develops an image for each character to be illustrated, then he searches for someone fitting that image. When he finds that person he can not help but say, "You are perfect for him, how would you like to be Dracula!" Naturally, most people are not sure whether he is joking or not. Soon they find that he is most serious and the process of making the hardware store owner into Dracula begins.

Who will become who, is also a matter of chance. Take, for instance, Dorothy in *The Wizard of OZ*. The search had been on for some weeks, yielding no definite results. One day a woman, who did picture-framing for Greg's agent, came to the studio to make a delivery. As the packages were being unloaded a young girl shyly walked into the room. She moved to her mother, wrapping her arms around her. Greg looked at her and cried, "Dorothy." The woman replied, "This is Dana, my daughter." That was true but to Greg she was also Dorothy. And Dorothy she did become.

The classics are first and foremost magnificent stories. They absorb us in adventure and suspense, they create atmospheres — a feeling of place in which we can move around. We discover these stories in our childhood, we come upon them in our adult lives and ironically they can seize us at either time with equal force. They are timeless because they speak to us of things that live emotionally, symbolically and silently in the crevices of personality. They are ageless because they reaffirm a basic universal value — faith in humanity. They are priceless because they can never be created in the same way by the same individual again.

So sit in that comfortable chair or recline in the grass, open the pages and submerge yourself. If it is the right story for the right time in your life, the book will gradually disappear. So will the chair or the grass. You find yourself, perhaps in a carriage, riding down a twisting dirt road, taking note of the wooden wheels sinking slightly in the mud. Eventually reaching exhaustion, you fall asleep and your head bounces dully from side to side, weighing heavily on your neck. But your mind dances with sights and sounds. You think you must be dreaming. Around the carriage are howling wolves, their teeth like razors bite at the night. The horses snort in shrills, their hooves pound the dirt and the stone trail. A cool, damp wind brushes your face, your body shivers, you shift in the seat. You squint through weighted eyelids but you cannot break into consciousness. Momentarily, you peer through at the team of horses. Strangely, they stand in place, their ears straight up, their breath hissing out into the night air. Wolves! — the driver, now standing beside the horses thrusts his arms wide in the air — the vicious beasts scatter. Does he control wolves! you think. But again you are bouncing and these thoughts skip through your mind.

In time the carriage halts. You awaken with the taste of sleep thick in your mouth. A castle looms hideous in the darkness, its stone walls stand like an ancient fortress. Up close the doors stretch above your head. They appear enormously heavy. You seek entrance through them into the room beyond. They are locked and a silence envelops you. Then a rattling, like chains, clinks in your ears. It deafens the warning voice inside you.

The door creaks open, first a crack, then some more. Suddenly a flickering lantern is thrust in your eyes. Through the flame is the shadowed face of a man, Count Dracula. Now you will be forced to live the rest of the adventure.

It is an old story but to you it is new. It will prove itself incredible. It is a classic.

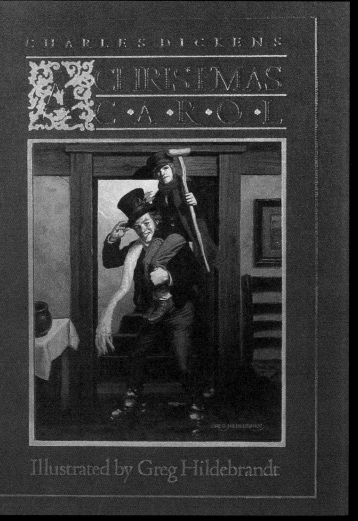

CHARLES DICKENS
CHRISTMAS
C·A·R·O·L

Illustrated by Greg Hildebrandt

"There is a feeling of awe and intimidation when I look at the finished book and see Charles Dickens name and mine on the same spine. I say, 'My god this is unbelievable. How dare I allow my name to be printed on the same book with this master?' That's the first feeling I have. Then I wonder if Mr. Dickens was alive, would he like these pictures? I wonder that always."

Proclamation

Let it be known to all men (and ladies), that I, Gregory J. Hildebrandt, extend my sincerest gratitude to the following friends, neighbors and members of my family who devoted countless hours while posing for the characters found throughout this edition of A CHRISTMAS CAROL:

Mr. Jerry Hallerman • Scrooge
Mrs. Barbara Hallerman • Lady—Blind Man's Bluff
Sherri Hallerman, Esq. • Nephew's Wife
Alan Hallerman • Young Scrooge
Linda Hanover, CPA • Lady—Blind Man's Bluff
Jeff Hanover • Nephew
Gary Hallerman • Bob Cratchit
Joseph D. Scrocco, Sr. • Marley's Ghost
Joseph D. Scrocco, Jr. • Old Joe
Jeannie L. Scrocco • Mrs. Fezziwig
Michael Paglia, D.D.S. • Mr. Fezziwig
Jean L. Gruder • Ghost of Christmas Future and Chamber Maid
Howard L. Gruder • Ghost of Christmas Present
Gregory J. Hildebrandt, Sr. • Man in Market
Gregory J. Hildebrandt, Jr. • Tiny Tim and Ghost of Christmas Past
Diana Hildebrandt • Mrs. Cratchit
Mary Hildebrandt • Cratchit Daughter
Laura Hildebrandt • Cratchit Daughter
Robert Sullivan • Undertaker

Gregory J. Hildebrandt

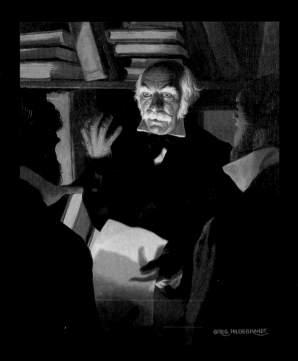

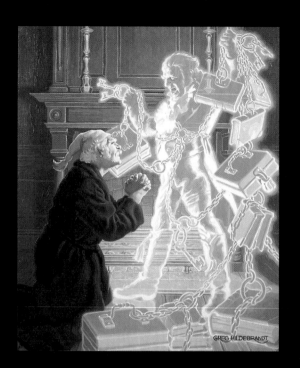

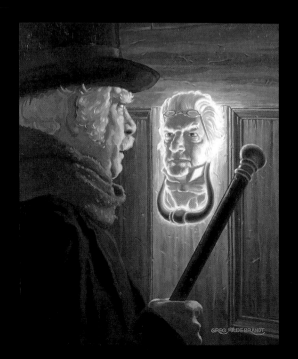

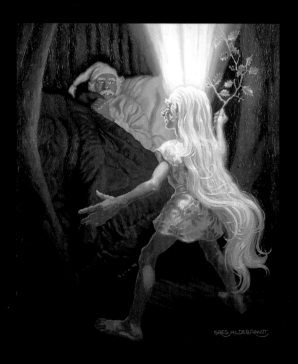

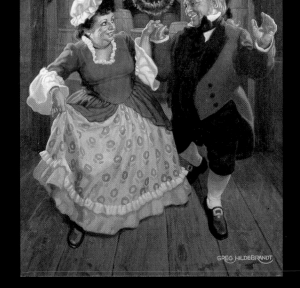

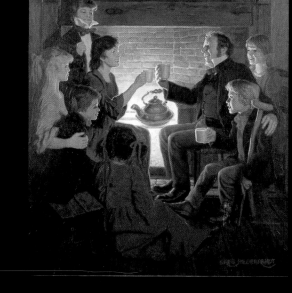

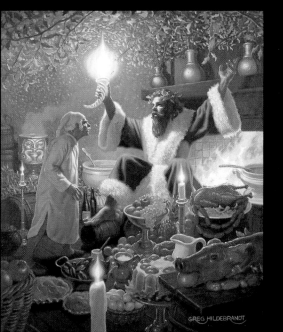

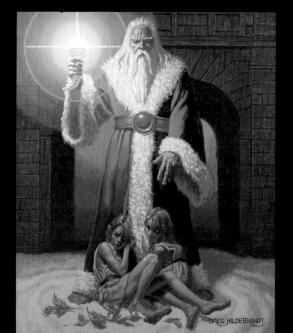

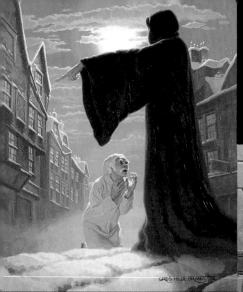

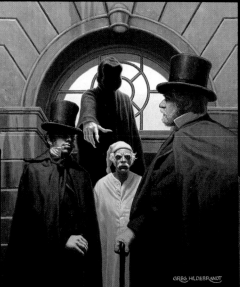

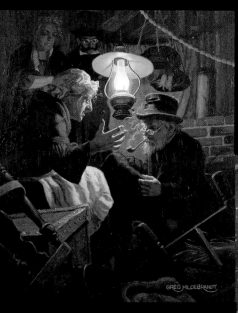

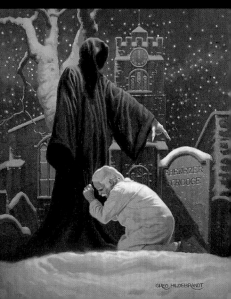

"The characters in this classic are so well defined.
Scrooge and his miserliness, the Cratchit family, the
spirits, the ghosts and all the other characters are ones
that I can get involved with in my illustrations. The
story itself, the transformation of a human being is great."

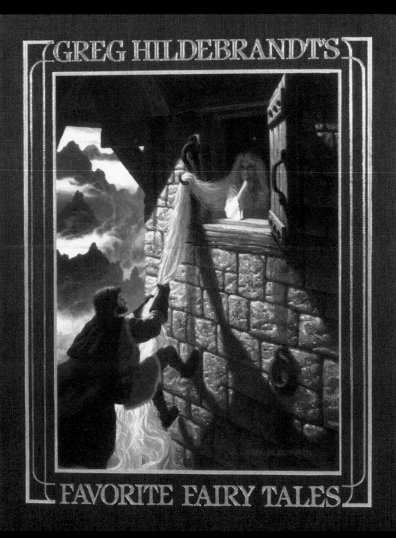

Acknowledgments

I would like to extend my deepest thanks to the following friends and family members who gave their time and efforts to pose for the characters in this collection of some of my favorite fairy tales.

Josephine Paglia	Shoemaker's Wife
Lou Paglia	Shoemaker
Joe Varenelli	Elf
Gregory Hildebrandt	Jack The Giant Killer
Anthony Marcantuono	The Giant Blunderbore
William McGuire	Rip Van Winkle
Ron Wagner	Sigurd
Robert Irsay	Sindbad
Eric Shanower	Perseus
Stephanie Irsay	Andromeda
Donna Cole	Rapunzel
Pete Dominick	King's Son
	Aladdin
Fred Jones	Genie from Aladdin
Robert Port, MD	Prince Ahmed
Amy Port	Perie Banou
Gene O'Brien	Schaibar the Genie
	Eshirit
	Lepracaun Poet
Michael Resnick	Aed, Chief Poet of Ulster
Howard Gruder	King Iubdan
Marla Maier	Queen Bebo
Joseph D. Scrocco, Jr.	Rumpelstiltskin
	King Fergas Mac Leide
Dawn Felauer	Miller's Daughter
Daniel Slater	Marble Statue
Jean L. Scrocco	The Little Mermaid
	Freyja
	Snowdrop
	Witch
	Evil Fairy
Johnathan Kenny	Hansel
Amanda Eyrich	Grethel
Tanya Irsay	Seven Good Fairies
	Little Girl
Steve Giovanni	Dwarf
Erika Connell	Little Girl
Andrew Connell	Little Boy
Nicholas Kenny	Little Boy
Dina Rosenkrans	Elsa
	Clay Statue
Mary Hildebrandt	Beauty
Melvin Slater	Old Man of Magic
Bernice Slater	Fairy Mother
Greg Hildebrandt	The Ratcatcher
	Dwarf
Craig Maier	Polyphemus the Cyclopus
Adam Kubert	Greek Sailor
Andy Kubert	Odysseus
Bjorn Ousland	Greek Sailor
Jay Geldhof	Greek Sailor
Erin Lyons	Kisika

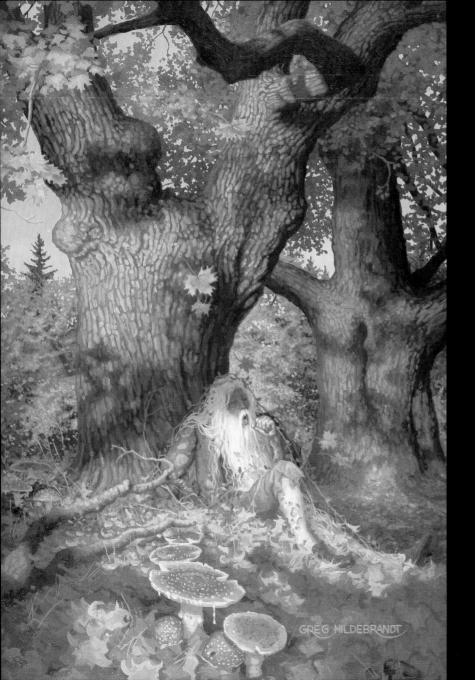

"In each of us there is a child and an imaginative person. I'm trying to reach that child.

"Kids are imaginative! They get it worked out of them by growing up. I think that people resent having to grow up and most of us still want to be kids. It's the freedom of imagination that's important and that's what I'm trying to reach with my art.

"In a book like the Favorite Fairy Tales, I'm painting individual characters from separate stories. There are more long shots in this type of illustration. It's less centered on the people because I have to sum up the whole story in one image.

"I tried to achieve a single window into each of these tales. I don't know if I have but I certainly hope so. If I succeed in creating a window into another world that allows someone to walk into it, they can walk away from their problems and into an adventure. That's like a vacation! When you're bored you want to escape into romance or action. That's what my art does for me and I hope it does it for other people. It's pure escapism."

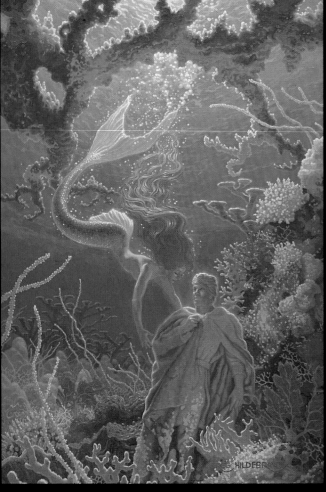

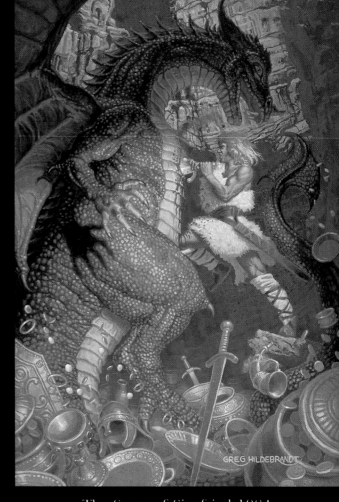

The Little Mermaid 1984

The Story of Siegfried 1984

Snowdrop 1984

The Story of Aladdin 1984

Beauty and the Beast 1984

The Pied Piper 1984

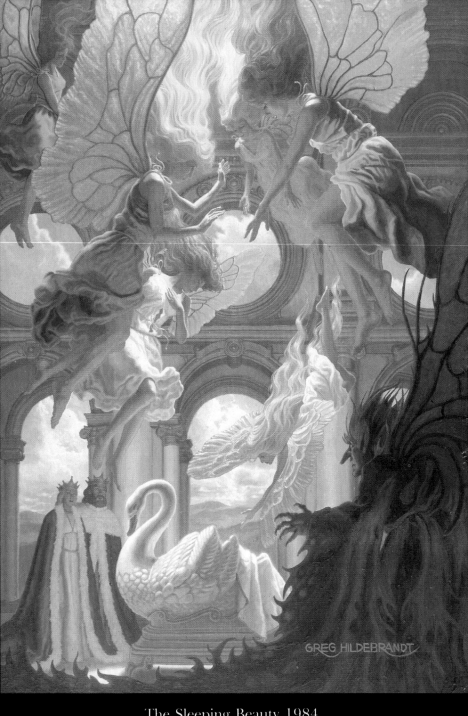

The Sleeping Beauty 1984

Jack the Giant-Killer 1984

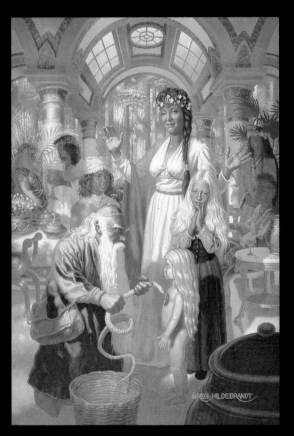

A Tale of the Tontlawald 1984

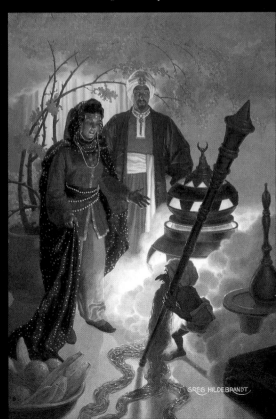

The Magic Carpet 1984

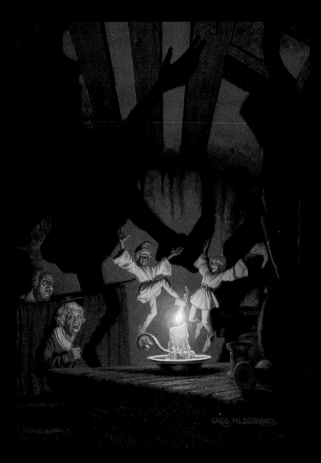

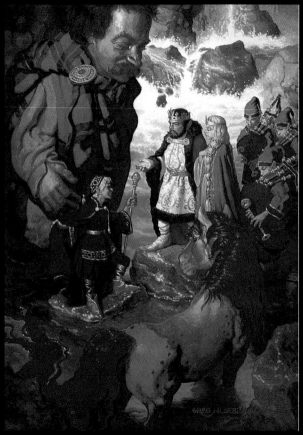

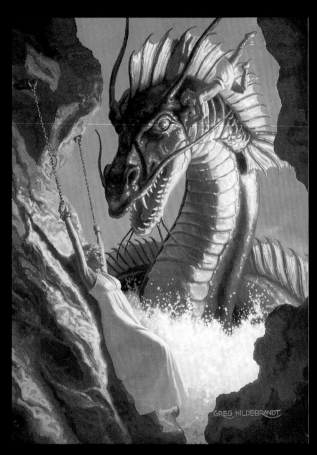

The Elves and the Shoemaker 1984 The story of Iubdan 1984 The Story of Perseus 1984

Hansel and Grethel 1984

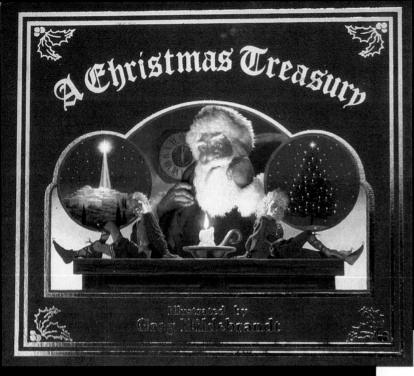

A Christmas Treasury

Illustrated by
Greg Hildebrandt

ACKNOWLEDGEMENTS

A very merry "thank you" to my friends and members of my family
who posed for the characters found throughout this edition of
A Christmas Treasury.

CAST OF CHARACTERS

Michael Paglia - Santa
Dena Hansen - Mary
Adam Kubert - Joseph
Joseph Scrocco, Jr. - Shepherd
William McGuire - Shepherd
Greg Hildebrandt - Shepherd, King, Sailor
Kevin McGinty - Angel
Alicia DeVincenzi - Child Caroling
Jim McCann - Child Caroling
Heidi Corso - Angel
Vincent Colandrea - Medieval Lord
Jean Scrocco - Medieval Lady
Ron Maiver - Squire
Honey Maiver - Lady In Waiting
Gene O'Brien - King, Papa ('Twas)
Linda Hanover - Young Lover
Alan Hallerman - Young Lover
Gregory Hildebrandt - Elf
Karen White - Elf
Robbie McCann - Child Sleeping
Annie Green - Child Sleeping

'Twas The Night Before Christmas

'Twas the night before Christmas,
When all through the house,
Not a creature was stirring, not even a mouse.

The stockings were hung by the chimney with care.
In hopes that St. Nicholas soon would be there.

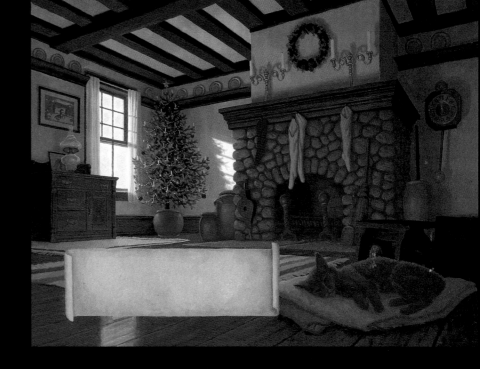

The children were nestled all snug in their beds,
While visions of sugarplums danced in their heads.

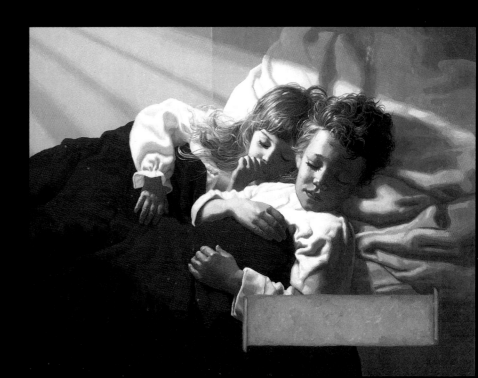

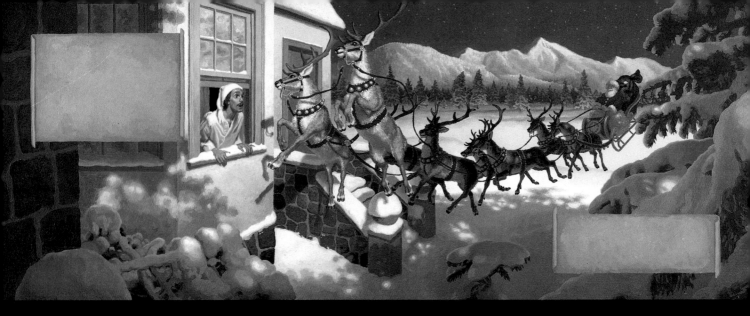

And Mamma in her kerchief, and I in my cap,
Had just settled down for a long winter's nap.

When out on the lawn there arose such a clatter,
I sprang from my bed to see what was the matter.

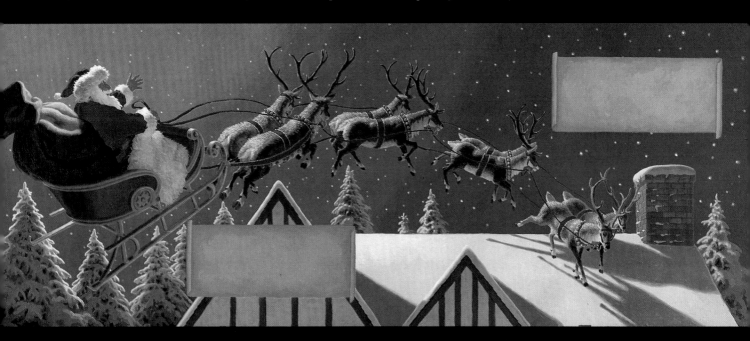

So up to the housetop the coursers they flew,
With the sleigh full of toys, and St. Nicholas, too.

And then in a twinkling, I heard on the roof
The prancing and pawing of each little hoof.

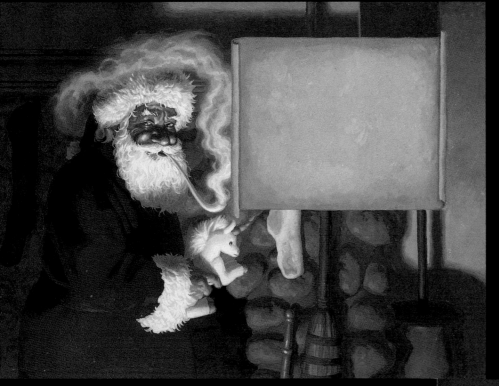

His eyes how they twinkled! His dimples how merry!
His cheeks were like roses, his nose like a cherry.
His droll little mouth was drawn up like a bow,
And the beard on his chin was as white as the snow.

The stump of a pipe he held tight in his teeth,
And the smoke, it encircled his head like a wreath.
He had a broad face and a little round belly,
That shook, when he laughed, like a bowl full of jelly.

He was chubby and plump, a right jolly old elf,
And I laughed when I saw him, in spite of myself.
A wink of his eye and a twist of his head,
Soon gave me to know I had nothing to dread.

He sprang to his sleigh, to his team gave a whistle,
And away they all flew like the down of a thistle.

But I heard him exclaim as he drove out of sight,
"Happy Christmas to all, and to all a good night."

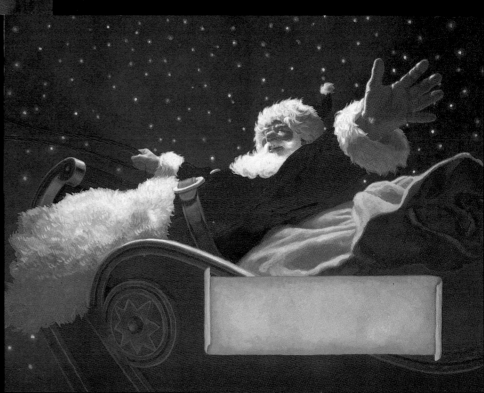

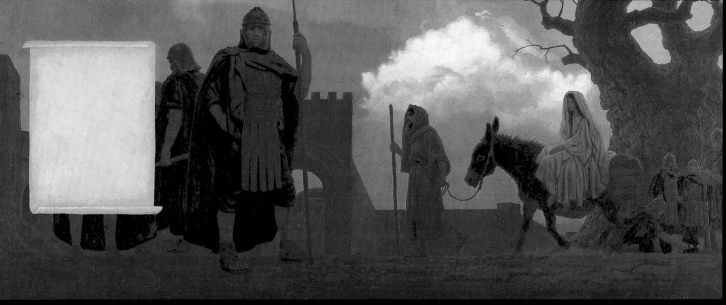

Everyone went to register, each to his own town. And so Joseph went from the town of Nazareth in Galilee to Judea, to David's town of Bethlehem — because he was of the house and lineage of David — to register with Mary, his espoused wife, who was with child.

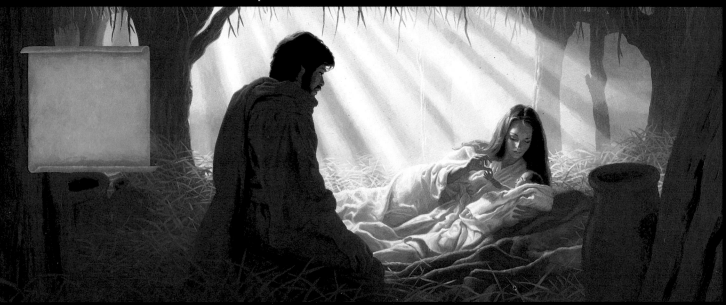

She gave birth to her first-born son and wrapped him in swaddling clothes and laid him in a manger, because there was no room for them in the place where travelers lodged.

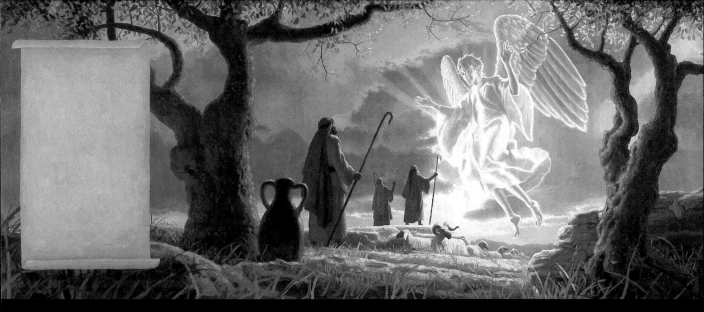

There were shepherds in that locality, living in the fields and keeping night watch by turns over their flocks. The angel of the Lord appeared to them as the glory of the Lord shone around them, and they were very much afraid.

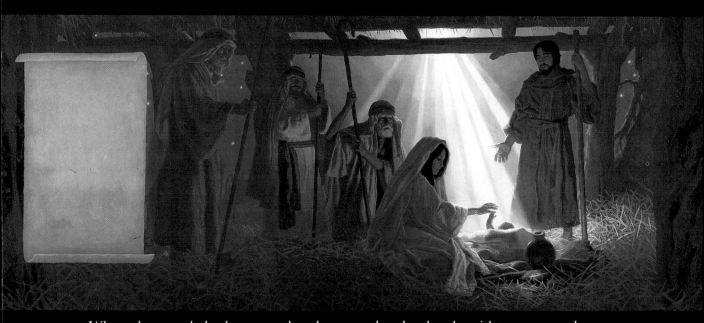

When the angels had returned to heaven, the shepherds said to one another: "Let us go over to Bethlehem and see this event which the Lord has made know to us." They went in haste and found Mary and Joseph, and the baby lying in the manger; once they saw, they understood what had been told them concerning this child.

Carols And Songs

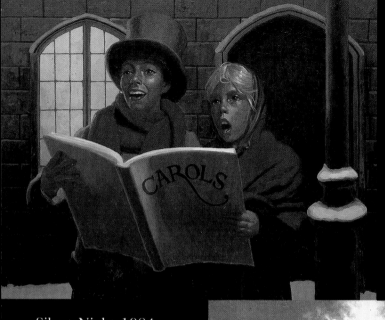

Silent Night 1984

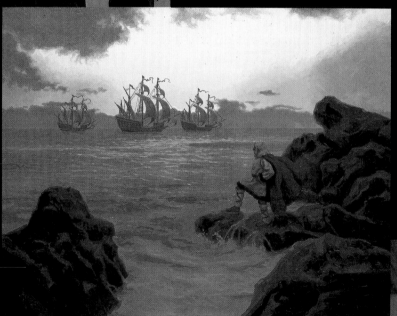

Deck The Halls 1984

I Saw Three Ships 1984

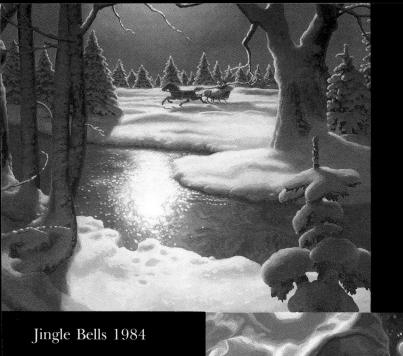

Jingle Bells 1984

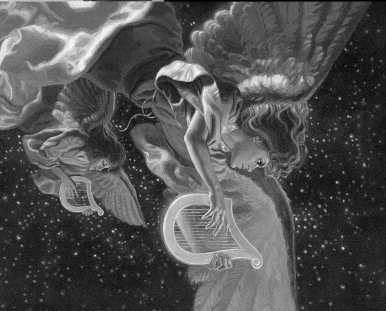

O Christmas Tree 1984

It Came Upon The Midnight Clear 1984

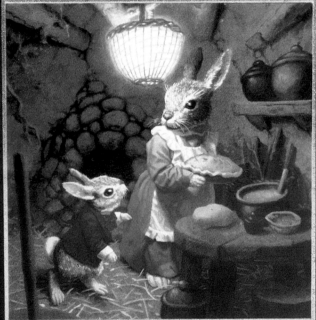

"At first I approached Peter Cottontail on a very negative level. I had done so many animal books before The Lord of the Rings, which was the kind of art I really wanted to do. At that time, I was taking all the work I could get to make a living and stay in the business.

"Don't take me wrong. I love animal classics. I loved them in Disney and Aseop's Fables but it was tough for me to try and get a handle on this rabbit and figure out an approach I wanted to take. I didn't know if I wanted it to be cartoony and then I decided I would approach it the same way I did the classics.

"That's when Peter became a challenge and an original. I realized I hadn't done this before. This was a whole new approach for me with animals.

"I really got into it and it was enjoyable. I was able to

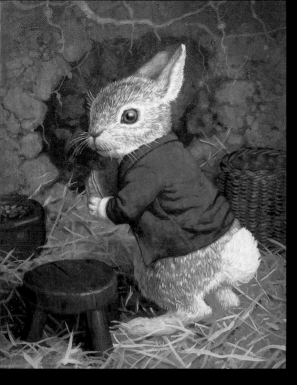

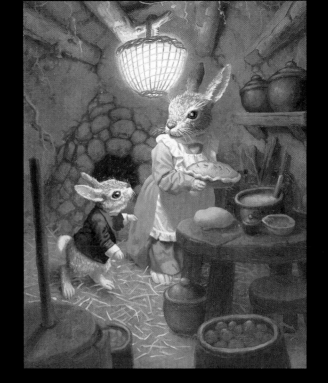

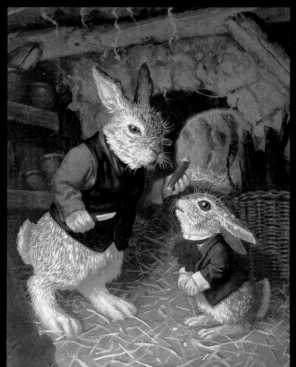

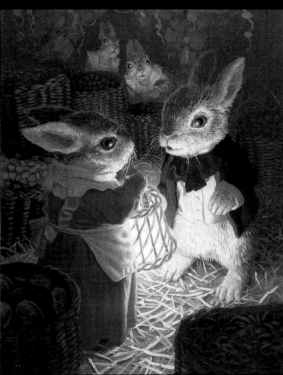

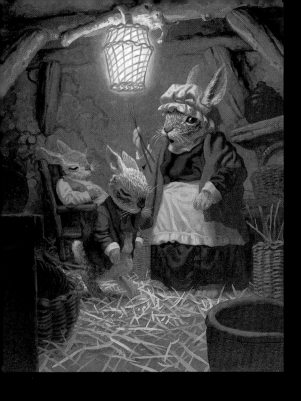

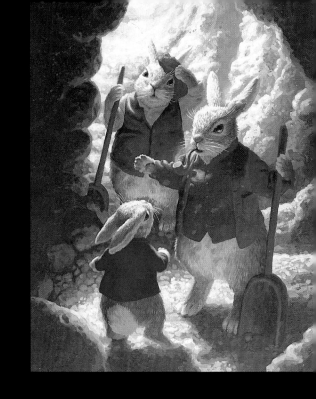

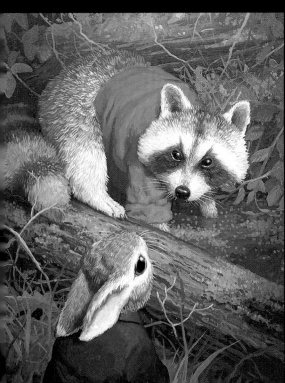

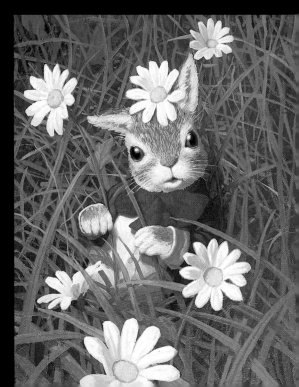

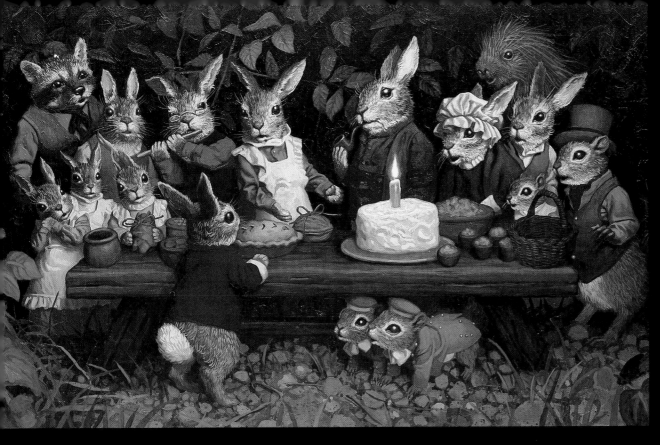

Once upon a time, in the woods not very far from here, there lived a young rabbit with soft sandy-brown fur, bright black eyes, and the cutest little white tufted tail you ever saw.

His name was Peter — as his father and grandfather and great grandfather and great great grandfather were named before him. Peter Cottontail.

As the sky deepened and the stars came out and the great round moon rose overhead, the animals feasted on woodland treats. Afterwards, They played games until the sky grew lighter and the moon began to sink.

"It's time for our Peter Cottontail to go to bed," said his mother and father.

Peter Cottontail went around and hugged each of his friends and relatives and thanked them for making such a wonderful surprise party. But he saved the biggest hugs for his mother and father.

"This is the most perfect day I've ever had. And you know what?" Peter Cottontail said. "Next time, I want to make the surprise."

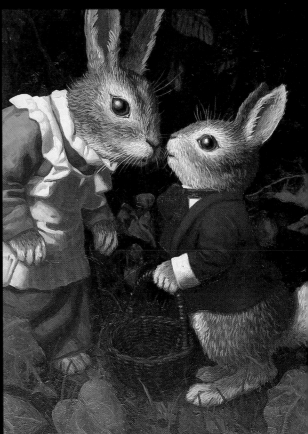

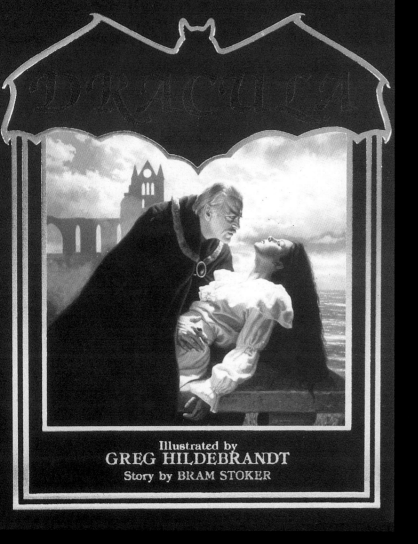

Illustrated by
GREG HILDEBRANDT
Story by BRAM STOKER

A sincere thank you to all my friends who put their fears aside, while entering into the Land of the Undead and posed for the characters found in this edition of Dracula.

CAST OF CHARACTERS

Vincent Colandrea • Dracula
Dena Hansen • Lucy Westenra
Anne Hoppe • Mina Murray
William Fredericks • Jonathan Harker
William McGuire • Dr. Seward
Al Hoppe • Quincy P. Morris
Michael Bialek • Arthur Holmwood
Michael Resnick • R.M. Renfield
Josephine Paglia • Romanian Woman
Greg Hildebrandt • Mr. Swales
Heidi Corso • Vampiress
Karen White • Vampiress
Jean Scrocco • Vampiress
Jose Rouco • Attendant
Joe Scrocco • Attendant
Gary Skoloff • Dr. Van Helsing
Evelyn Enteman • Mrs. Westenra
Pixie Esmonde • Lady in Piccadilli
Gene O'Brien • Dead Sea Captain

Reference material for Transylvania and the Castle Dracula • compliments of:
Aurelian Paraipan
Director Romanian Library, N.Y.

"When Frank Langella decided he would write the introduction to this book I was very honored. Mr. Langella's portrayal of Dracula on stage and screen has always been my favorite. He portrayed Dracula the man and the romantic. I

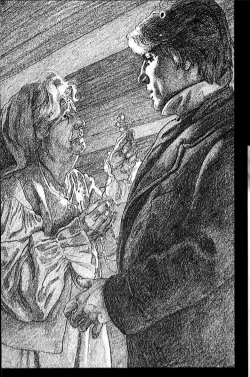

The Rosary 1985

"Dracula has always been a favorite of mine. I love the idea of contrast. It's like light and dark or cool and warm or good and evil."

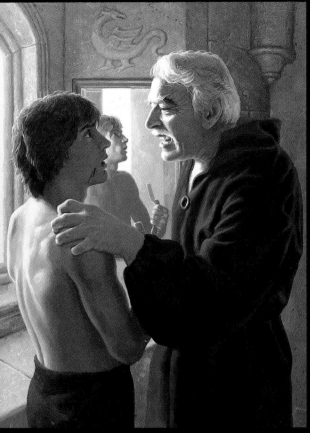

The Demonic Fury 1985

A View of Horror 1985

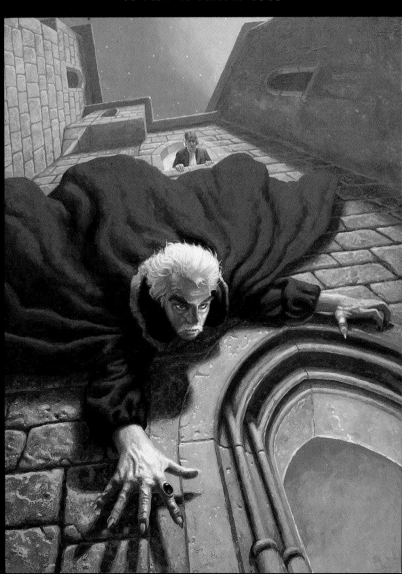

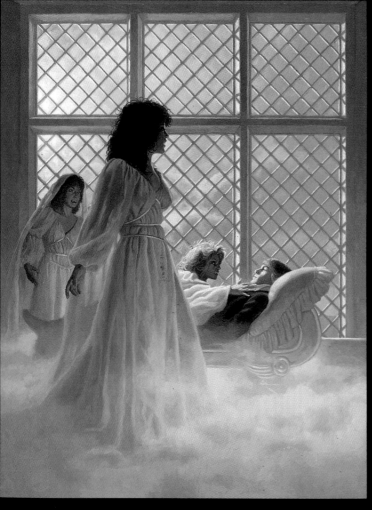

Jonathan Dreams of the Vampiresses 1985

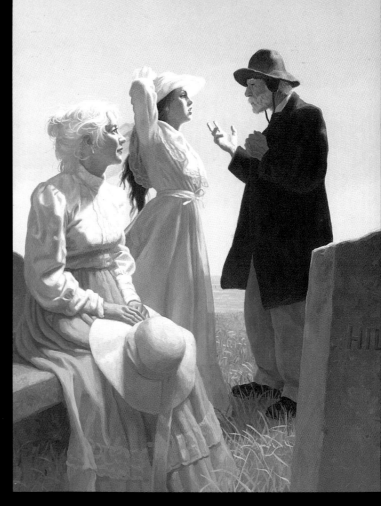

By the Sea 1985

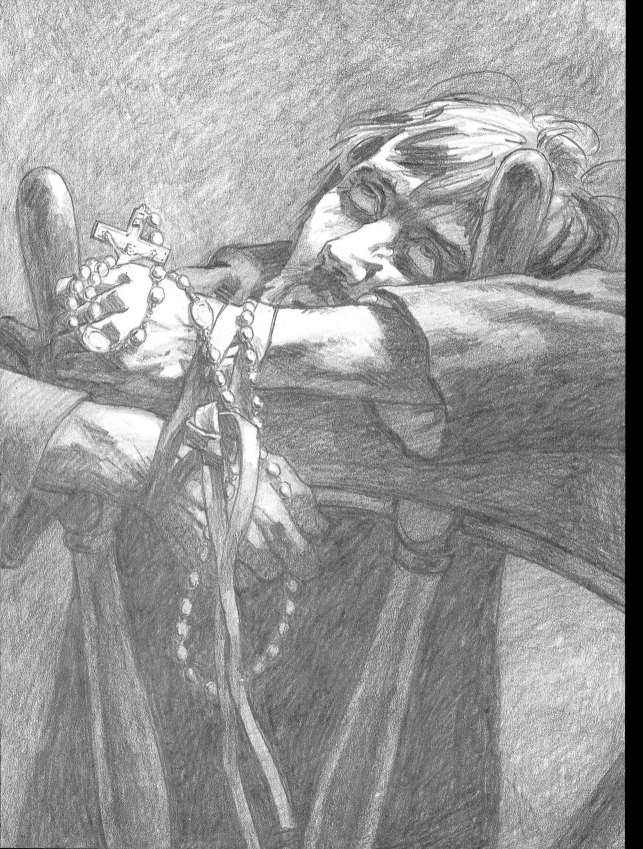

Sh

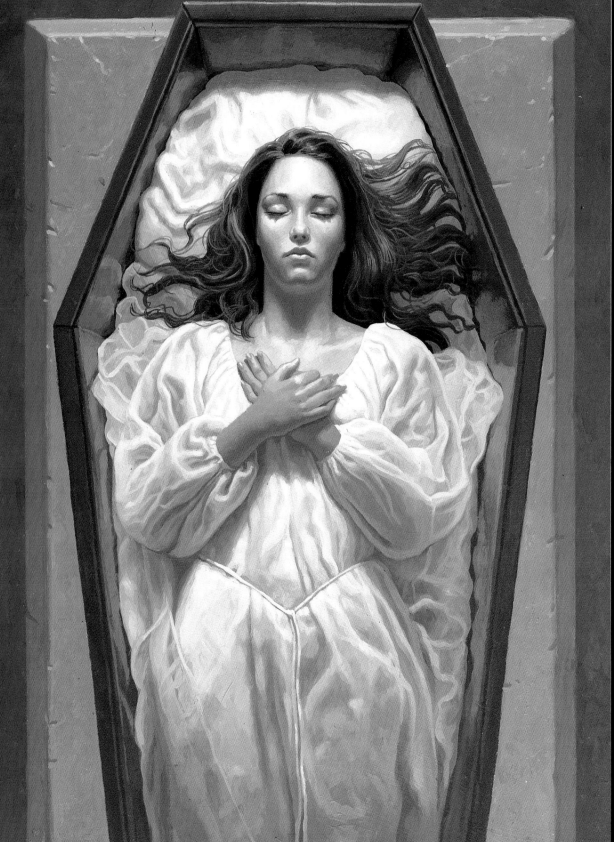

Miss Lucy's Resting Place 1985

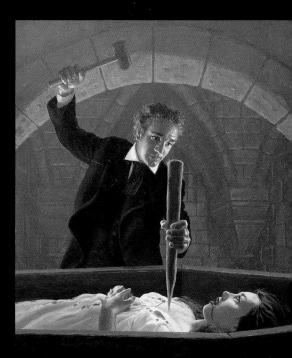
Arthur Frees His Love's Soul 1985

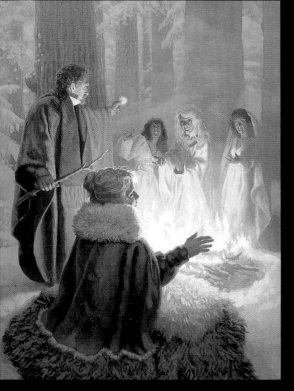

The Circle of the Host 1985

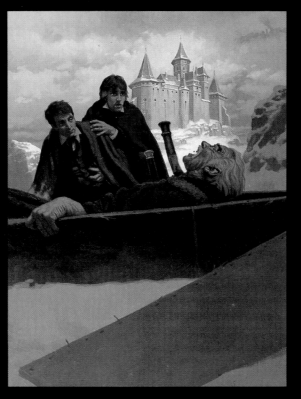

Dracula Perishes 1985

The Loss of a Friend 1985

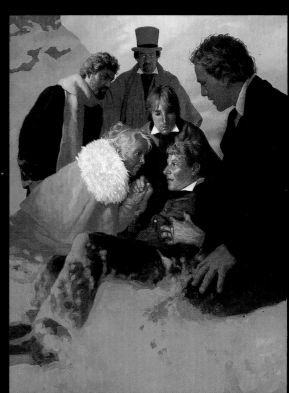

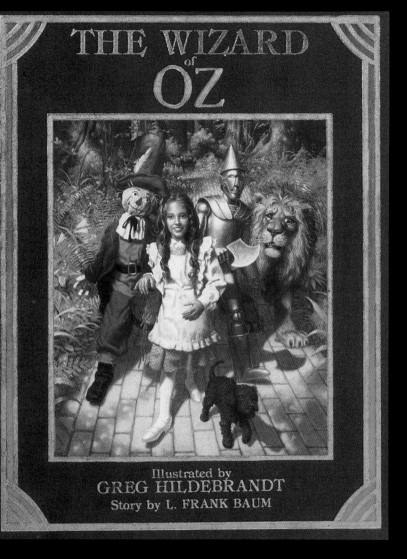

THE WIZARD of OZ

Illustrated by
GREG HILDEBRANDT
Story by L. FRANK BAUM

I would like to thank my family and friends, for following my brush and me down the yellow brick road to the Emerald City, and taking the time to pose along the way for the characters found in this edition of The Wizard of Oz.

CAST OF CHARACTERS

Michael Paglia • The Wizard
Dana Devins • Dorothy
Evelyn Enteman • Aunt Em
Greg Hildebrandt • Uncle Henry
Germaine Hildebrandt • The Good Witch
Jean Scrocco • The Wicked Witch; Oz as a beautiful lady
Gene O'Brien • Soldier (The Army of Oz); Flying Monkeys
Michael Resnick • Guardian of the Gates
Heidi Corso • Glinda
Joyce Dickson • Dancing Munchkin; Oz Citizen
Michael Dickson • Dancing Munchkin; Oz Citizen
Penny Sergeff • Munchkin Grandmother; Oz Citizen
Robbie McCann • Munchkin; Oz Citizen
Stephanie Peters • Munchkin Child; Oz Citizen
Joey Martinez • Bog
Mary Hildebrandt • Bog's Wife
Joseph Scrocco, Sr. • Oz Citizen
Jeannie Scrocco • Oz Citizen
Heather Hawes • Oz Citizen; Winkie
Joan Foley • Oz Citizen
Judy McCann • Oz Citizen
Bill McGuire • Oz Citizen
Gregory Hildebrandt • Oz Citizen
Laura Hildebrandt • Oz Citizen
Delfino Falciani • Winkie
Bob Smith • Winkie
Karen White • Winkie

Toto • Compliments of:
Second Chance Pet Adoption League

Models Made by Greg Hildebrandt for:
Scarecrow
Tin Man
Lion

"The fact that Margaret Hamilton wrote the introduction for my *Wizard of OZ*, just before she died, was very emotional for me. I was always a real fan of hers from the first time I saw her play the Wicked Witch of the West in the Judy Garland film to her coffee commercials as Cora. It's kind of a rare situation. I feel very priviledged to have her as a part of my book. That's why I dedicated it to her memory."

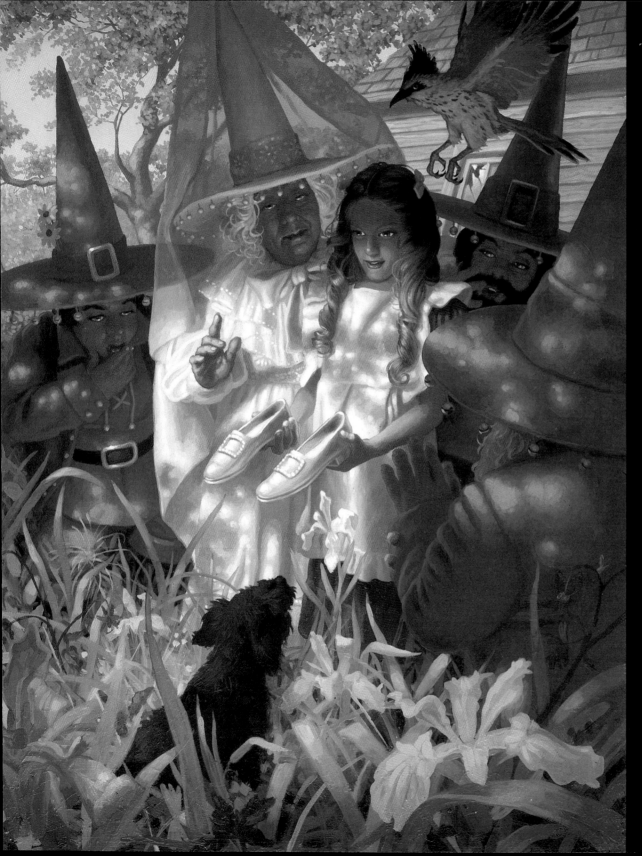

The Good Witch 1985

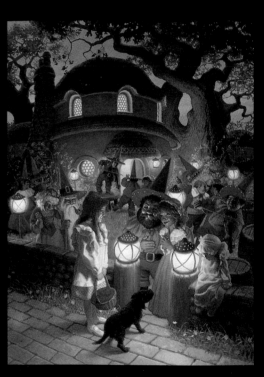

The Munchkin Party 1985

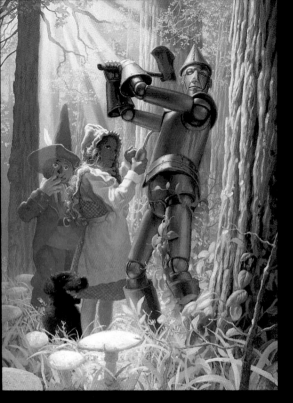

Dorothy Finds the Tin Man 1985

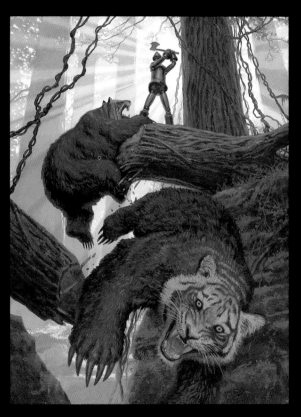

The Kalidahs Attach 1985

The Deadly Poppy Field 1985

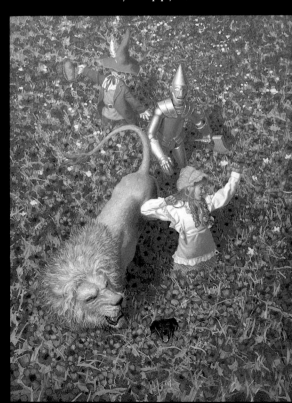

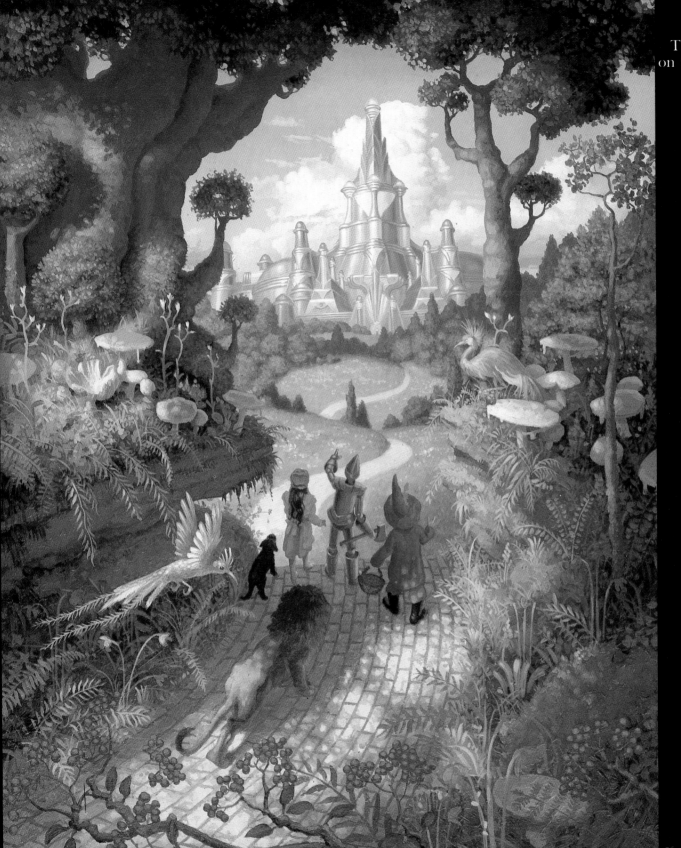

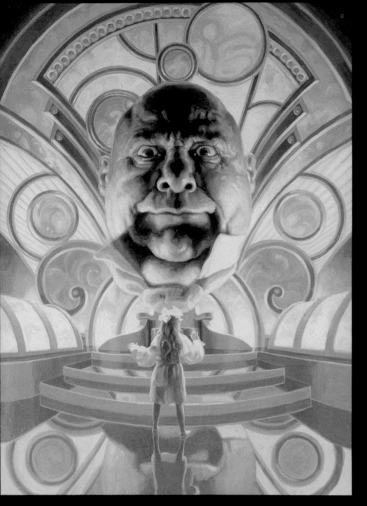

OZ The Great and Terrible 1985

The Scarecrow Enters the Great Throne Room 1985

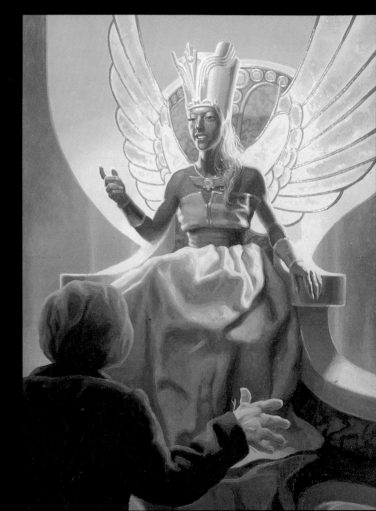

The Wicked Witch of the West 1985

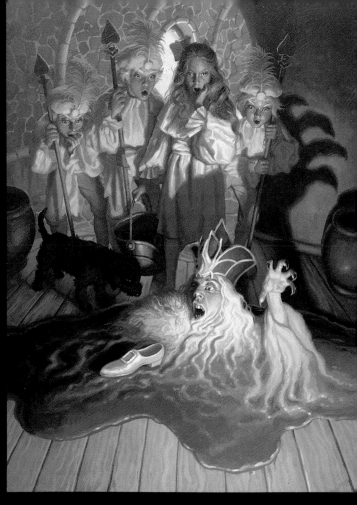

Dorothy Melts the Wicked Witch 1985

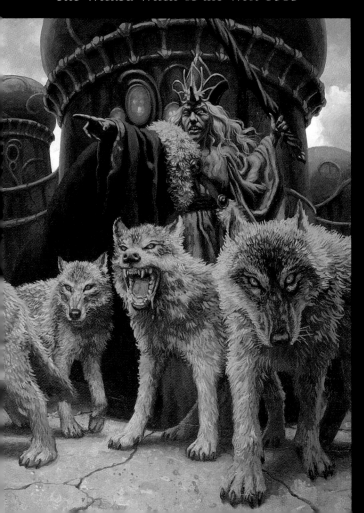

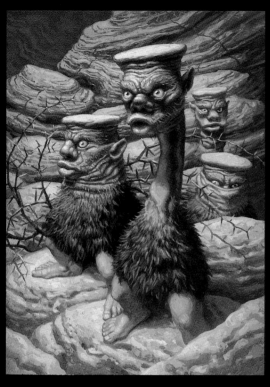
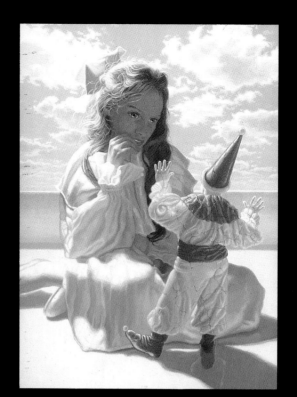
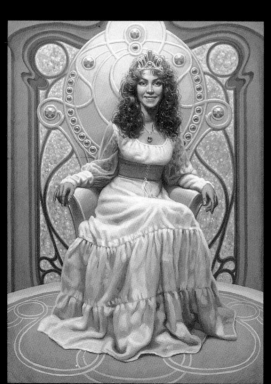
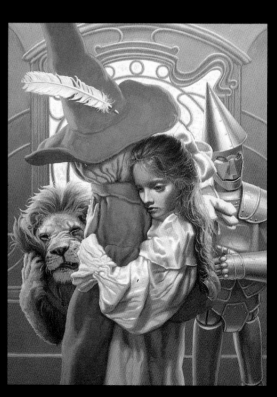

An Interview with the Artist

Q: Can you picture your life without art?

A: For me, art is my life. It is the center of my being. I need it like my body needs my heart to pump my blood or my lungs to breathe. It is absolutely necessary to sustain my life. Let me be clear, it's the making of art that is vital to my life. The act of living by itself is not enough for me. My life exists for creating art.

Q: How is your art influenced by nature?

A: Totally! I'm a realist and a representationalist. Obviously realism does not apply to a painting of a Balrog from the Lord of the Rings. But I paint it realistically even though it doesn't really exist. To paint a picture of a creature like a vampire, or a monster like the Balrog, you have to go to nature. They each have elements of human shapes so you need to derive them from reality. Nature is always there, even with the most fantasmagorical situation. If I want to paint an imaginary world, I still have to use the laws of this world. An example of those laws is the way light affects a given subject regarding highlights and shadows; and how the color of the light affects the colors of the objects. I have to study what each light source does to any given color and then apply that to each fantastic situation.

Q: Then, even when you are painting an imaginary world, everything is a takeoff on something that already exists?

A: Absolutely! It has to be. It's like trying to come up with a new color. You can't do it. You can make combinations of the existing colors. But you are always dealing with the primary colors: red, yellow, and blue; and everything is derived from that. If you paint a scene of an imaginary world, even though it's on another planet in another solar system, you still have to paint that scene with your knowledge of light that's based on the spectrum of the natural world — our natural world.

Q: Would you say that you actually go into another world or zone when you paint?

A: Yes. I'm like *Alice Through the Looking Glass*. I move through the experience — through the invented world; and then get out of it all kinds of unexpected things. I say I leave this world, yet I totally depend on this world to invent the world I am going to escape into. I can go and invent a world, whatever it may be, and get totally lost in it. I can travel anywhere, go anyplace on my drawing board. I can climb mountains or go into outer space. I can do that with my art and probably get almost the same thrill as those who really do it. I think this idea connects to the idea that it is a lot better to fight wars on paper than it is in reality. And that's one way I think fantasy art is good. You can swing swords and go on all kinds of adventures and you don't have to hurt anybody.

Q: Do you create for yourself?

A: Yes! I am making myself happy. I'm enjoying it. Hell, if I didn't, I wouldn't do it. I also depend on other people enjoying it. In other words, if I had to go into a closet and paint and no one would ever see it, I'm not sure if I would or could continue. It depends on my doing it and enjoying it and needing people to appreciate it. It's like an actor, he can't act in a closet either. He needs to be out on the stage to get the response from people and that's what makes it worthwhile. If I illustrate a book and get a good reaction to it, it's very gratifying.

Q: People know your art when they see it. You have attained a specific look and style. What about art as a career for youth?

A: I think everything I have said about art being life itself would apply. It is an exciting career. But only if you are willing to pay the price. If that's what you go after, then you can't go after 50 other things. You have to work very hard at it. It has to be an obsession. It has to be the motivating factor of your existence. If it isn't, forget it! Go do something else.

Q: Your art has been influenced by many of the great illustrators of the past. It depicts different styles even though you have your own style now. What would you say to a young artist starting now about a point of departure regarding the great masters?

A: I believe like Salvador Dali said, "Go learn how to paint like the

masters and then do what you want to do." And that's very true. Take any person you are inspired by, and imitate the hell out of them. Do it like crazy, and then your own style will gradually emerge. There was an obsession with style while I was growing up. Even now people say, "I feel that I have to come up with a personal style." Well, a style evolves like a personality does. Your inspired by other people and you imitate them and you grow from them.

Q: Who were you most inspired by?

A: N.C. Wyeth, Howard Pyle, early Disney and the Renaissance Masters.

Q: What was it about these people that first caught your attention?

A: Definitely their subject matter. I believe in strong subject matter. The subject is very important to excite me or inspire my imagination. It was also their use of color, light and composition.

Q: Were the artists that inspired you realists?

A: They all were. I consider even the early Disney art realism. The form that it took was a cartoon but it moved and conveyed a story. It made you cry! It made you laugh! It terrified you! It inspired you! That's what the early illustrators did for me and I'm trying to do it with my art.

Q: You work tremendously long hours and you are always trying to find something new, something that's better than you did before. Why?

A: That's what I believe life is all about. I think the whole idea is to keep developing, to keep evolving up a spiral. You start, and you go higher and higher, and you learn more and more, and you keep getting better and better. You never want to stop on your way up the spiral and say "This is it."

Q: Do you think people really see the changes in your art? Or have you reached a level where just you see the change?

A: Yes. Some people look at my art and notice changes in my use of color, light and composition. Some say "You're getting better." Good, I'm glad! I'm glad to see that I didn't backslide. Even if one person who knows my work from the past says it, it means a lot to me. It's proof that it's all worth while.

Q: Your career switches around from classic book illustrations to advertising art; from book covers to your personal paintings and collector's personal fantasies. How do you gear yourself into these switches of art moods?

A: Discipline! Learned discipline. You have to learn it like you learn mixing the colors. You're young and you want to run around outside and you have to force yourself to stay at it. I don't know what keeps me at it. I have no idea. It's a compulsion; but I have to be able to turn off one thing and turn on the other and I just do it.

Q: You've done jobs that haven't been favorites! Jobs to make a living and keep going to get to a point in your life where you could do exactly what you wanted to do. As a professional, is there any secret to getting through the job that you don't want to do but you have to do?

A: Eating! If you want to eat, you will get through it — hoping you can get to that point in the future where you will be doing what you want. It's always hoping that tomorrow is going to be better.

Q: When you're involved in a book project, do you become a part of the book? Are you involved in the story itself?

A: Yes! I get involved with the characters and environments. There is a wonderful thing about this kind of art. I become a part of all the people and the trees and the sky. I feel it and smell it.

Q: Do you find that there is maybe one particular character that you get close to or relate to?

A: Probably at times. For a minute or two. But the scene I'm working on at the moment is the ultimate scene for me.

Q: Then your research is just as important on the main character as it is on the most insignificant element in a book?

A: Absolutely! It has to be extensive in all cases. But the characters and the environments are all equally important. They are all reflections on the same plane.

Q: Do you have a special love for the classics?

A: Yes. This goes back to the first film I ever saw, Disney's *Pinocchio*.

From that point on classical tales became a passion of mine. My parents were very much into classics like the *Arabian Nights* and *Robin Hood*. It started back there. Now I am finally coming home to what I wanted to do all along. For me it is the pinnacle. They explain it themselves. They are called classics for a reason. They talk about the whole human condition, justice, injustice, love, hate, honor, mercy, sacrifice, all the virtues and vices of humanity.

Q: Do you think you have captured what these great Masters of literature would have wanted?

A: I can't answer that, but I hope so!

Q: Have you captured it for yourself?

A: Sometimes. I have an image of what I want to paint. I hope it will be a really truthful work and the best that I can do. Then there is a lot of energy and belief put into it. Then it's over, and I look at it and I say, "Did I make it." Sometimes I feel that I didn't, that I didn't do the subject justice. And then I can look at it in another moment, on another day and say "Hey that's not bad." And that flips back and forth until finally the piece is lost in the stream of oblivion somewhere. Then ten years will go by and I'll look at it again and sometimes I like it and sometimes I don't.

Q: The first classic you illustrated was *A Christmas Carol* by Dickens. Why was this chosen first?

A: That story has moved me since my childhood. The Alistair Simm movie version, which I loved; recollections of the book; and my parents' love for the characters kept it in the back of my mind. It just kind of surfaced and there it was.

Q: Looking at the proclamation page in the Christmas Carol it is obvious that over 50% of the people who posed for your characters are of the Jewish faith. When you chose these people and asked them to pose for these characters in a primarily Christian Christmas tale, what was there reaction?

A: Everybody took it in good nature. Dickens' story transcends religion and encompasses humanity. I think the people who posed recognize that it's a human- centered story.

Q: In terms of race or religion, do the people you ask to pose cross over a lot with the characters they are posing for? For example, when you are posing Arabian, Jewish or christian characters, does anyone have a problem when you ask them to pose?

A: So far no! I like the idea of mixing it all up. It says we are all people, all human beings. You can have any belief but all of us have a common center. I think that's the beauty of this kind of art. That's what the classics are all about — the human center that transcends any particular ethnic views even though the story may be ethnic. They transcend the times in which they were written. That's why they are classics and are still here a hundred or two hundred years later.

Q: When I look at this art I see pure fantasy and dreams. I go into a world that's not here but it's real. I jump into the reality of your art and your characters. Do you think this kind of art is good for little kids?

A: I think it's great for little kids. As a kid, I always remember wanting worlds to escape into. If you can create a real world that a kid can walk into, play around in and then come back home, it's good. That's why I believe art can't ever be too realistically rendered.

Q: The second classic book you illustrated was *Greg Hildebrandt's Favorite Fairy Tales*. Each fairy tale is illustrated separately. Is this kind of book more enjoyable for you than illustrating a story where you are continuously painting the same characters over and over?

A: No. Painting the same characters over and over is a situation that I like. I can explore a character just like an actor. I go through mood changes and shifts in attitudes and I enjoy that.

Q: Next you did a book called *A Christmas Treasury*. It has 'Twas the Night Before Christmas and the Nativity and Christmas songs all together. But you've already done 'Twas the Night Before Christmas. Why did you do it again?

A: I wanted to do it more realistically. I also wanted to get nostalgic with it. Since the story was a childhood favorite of both mine and Jean Scrocco, my publisher, we decided to go back to our favorite Christmas memories. I got old pictures of my parents' home and Jean got old pictures of her grandparents' home and I combined them to illustrate this story.

Q: Then you entered a land that is totally unknown; you jumped into the land of *Oz* by L. Frank Baum. Were you excited about the *Wizard of Oz?*

A: Yes. I was excited! But I had a lot of mixed feelings of intimidation from the pre-existing material. Since all the original books were illustrated, I had to deal with Denslow's and Neill's illustrations; and then the MGM film with Judy Garland. The film is riveted in my mind as much as anyone else's. I've probably seen it 50 or 60 times. It sits there chiseled in my mind. This is *Oz*. So how do I face that? Do I incorporate some of the original characteristics from the film; or do I ignore them? That's what I ended up doing, blocking them out and looking at Baum's text exactly as it came off the pages. I illustrated what was there and invented things where it was possible. That was great!

Q: Then you went into a totally different zone and you jumped from the Emerald City into the land of the vampire — Bram Stoker's *Dracula*. This is a real contrast. The paintings are tremendously different in these two books. Why?

A: The story and the subject matter dictates the difference. The colors in the text of *Oz* are all bright. In Dracula, it's the opposite. It's death, evil, darkness, night and romance; and it's a completely different set of color values.

Q: How do you feel about the character of Dracula?

A: He's a great character! He is one of a kind. He has always appealed to me. I used to dress up as Dracula in my younger days. I love him.

Q: What is it about this character that intrigues people?

A: I guess people are generally intrigued by satanically evil characters. The idea of eternal life is also intriguing. Then of course there is the romantic aspect of him. That's very strong.

Q: When you were growing up, Dracula as a character scared you. Can the kids today relate to Dracula or is he too sedate for them?

A: I think that the concept of a vampire continues to be as thrilling and mysterious as it ever was. And I think good art and literature will always surface.

Q: How much time do you spend on your art in any given year?

A: Generally on an average it's 6 days a week all year long about 10 - 12 hours a day. So it's constant. Even in the off hours my mind doesn't stop.

Q: Do you ever feel like you can't come up with one more idea?

A: It's true! Absolutely! The well runs dry. You can't milk it like a cow. But that is also a momentary situation. I then take a break and do something else. I hope I never go into that permanently.

Q: I have heard you use a phrase "A conspiracy of excellence," what do you mean by that?

A: It's a play on words! People think of conspiracy as wrong- doing. But you can conspire to do something excellent and it seems to me that is needed today. You remember the old fashion standard of well-made objects. There are conspiracies everywhere now for better quality. To make it good! To make it excellent! To make it last!

Q: What is the role of an artist in society?

A: The ideal role or the pinnacle is to elevate consciousness. Like the ancient Greek idea — a play was supposed to transform you not just be entertaining. To transform society.

Q: Looking back on your life and the hundreds of paintings you've done, are you happy with the work you've created?

A: There are obviously things I would change, but overall I think I'm headed in the right direction. I'm never really totally satisfied with my work. I think that's what drives me on. I feel the next piece will be it — the one that's going to be perfect. And yet if I really face it, I know that it won't be! That goes on and on. You never know. You can't project on a scale of 1 to 10 and think you're going to end up with a 10. I know I'm after perfection. If I get rational about it, I would say 'NO', I'll never find it. I would say that it's a quest. It's exploration; but I never explore the territory completely.